Oberammergau

ART, TRADITION, AND PASSION

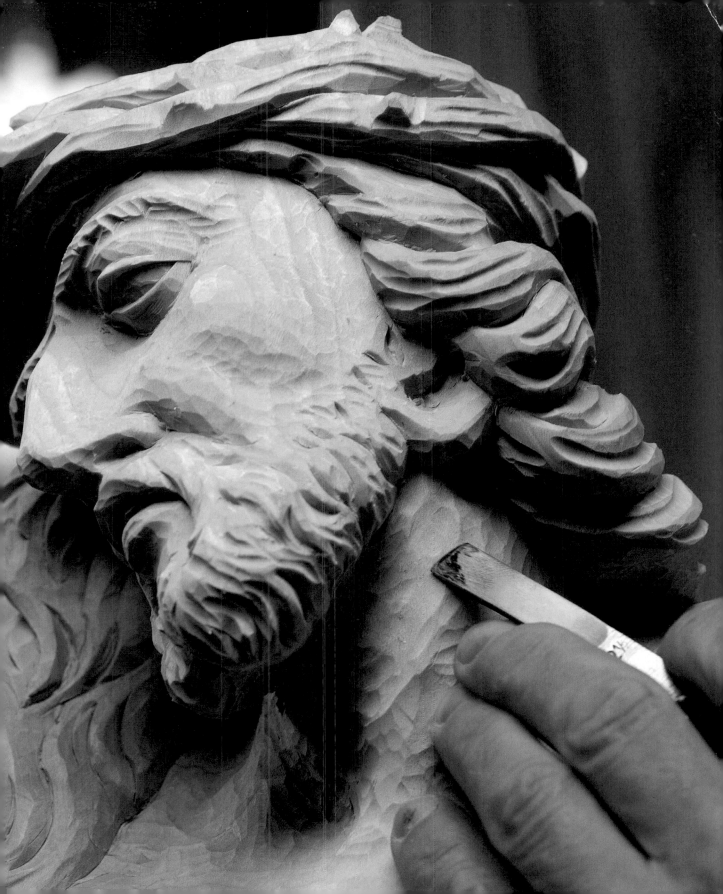

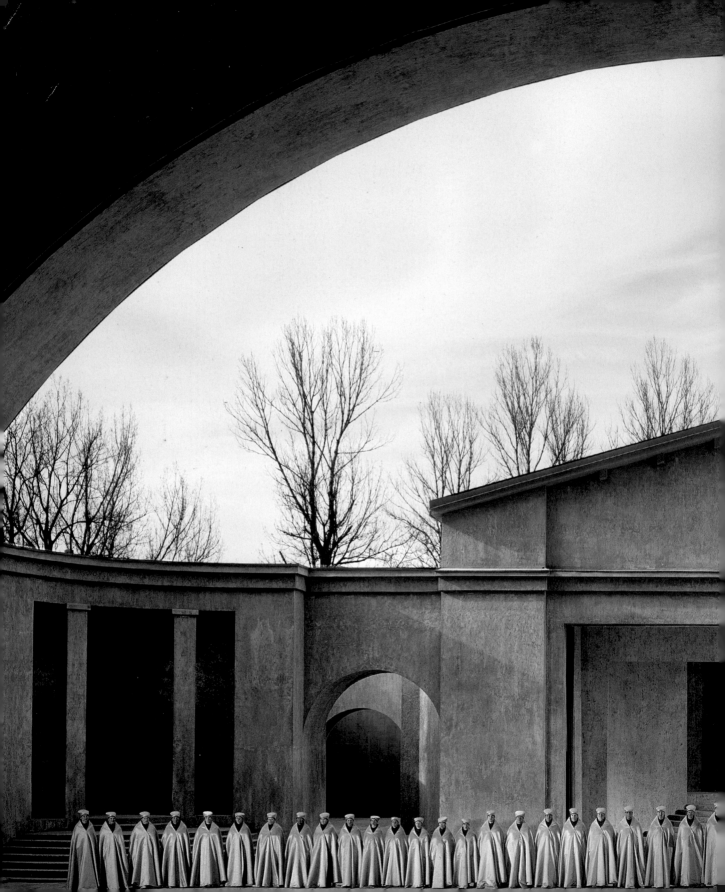

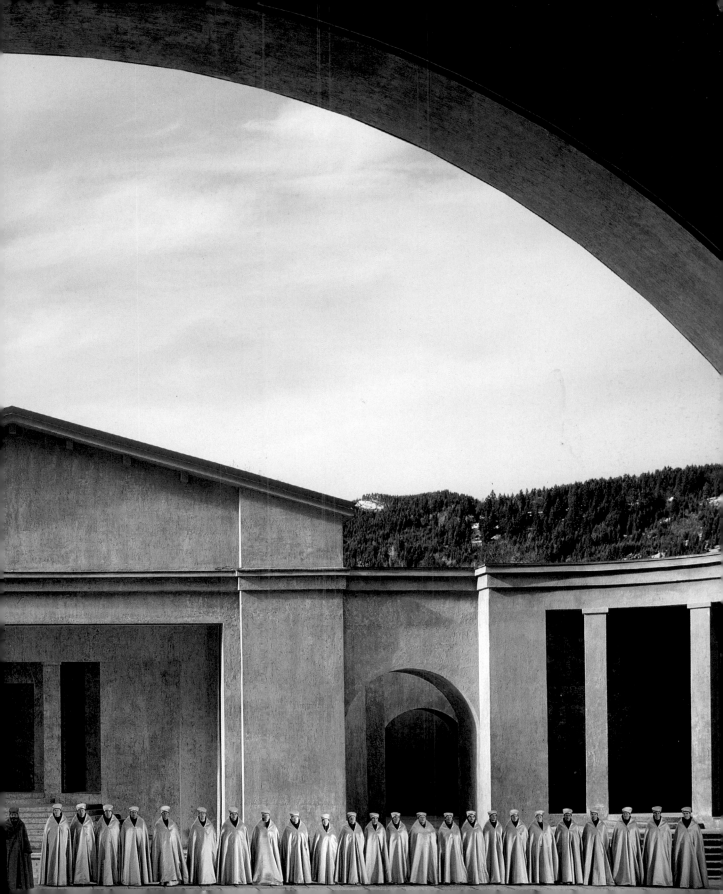

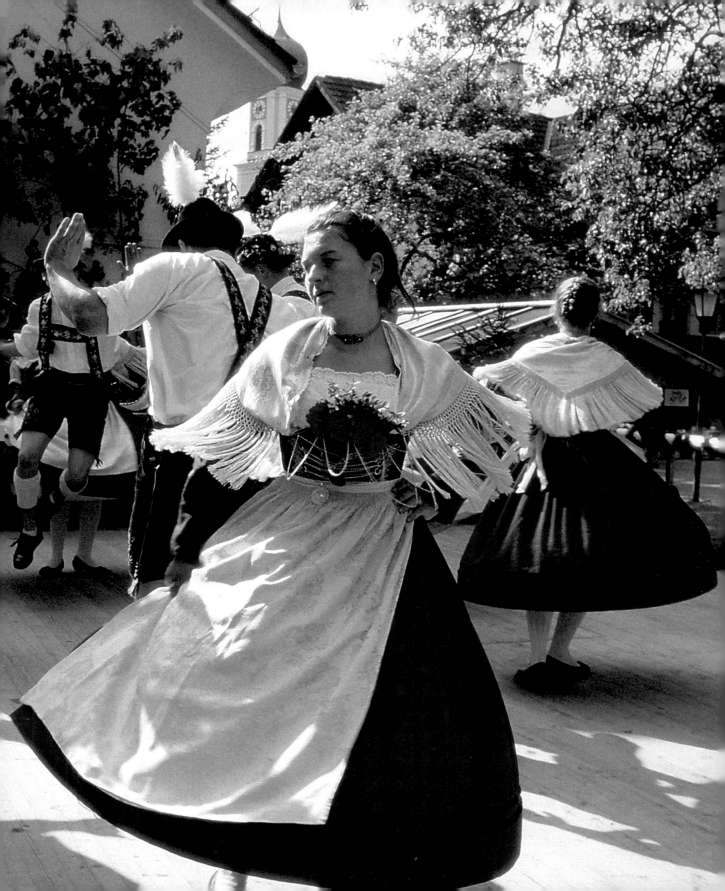

Oberammergau

ART, TRADITION, AND PASSION

Annette von Altenbockum

PRESTEL

Munich · Berlin · London · New York

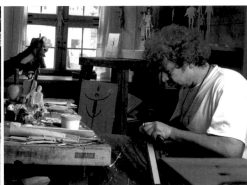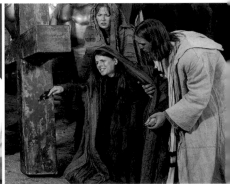

 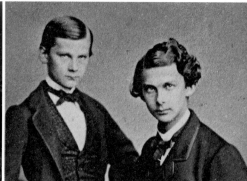

Almost Heaven

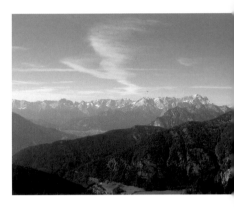

What kind of a special place is it that has felt bound for 375 years by a plague vow taken in 1633 and, in an unparalleled communal achievement, stages the most famous Passion play in the world every ten years? A place also known as the "village of crucifix carvers." Is Oberammergau a "holy village" that sees itself as the last bastion against the rejection of the Christian faith? The people of Oberammergau smile to themselves at such conjectures, for they know better: Here, like anywhere else, people doubt, argue, reconcile, and love: perhaps just more fervently and communally than elsewhere. Although the character of Oberammergau is profoundly shaped by the Passion plays, it would not do the village justice to consider only this aspect. In addition to its particularly distinctive culture of theater, Oberammergau should be explored for its great affinity for music, art, and culture, its ability to recount a varied and exciting history, and its glorious natural setting, which can scarcely be surpassed. Artists and artisans have lived and worked here for generations; their number has been growing again for several years, promising to make Oberammergau once more a center of Alpine craftsmanship. Besides culture, tourism has also played a significant role in Oberammergau since the end of the nineteenth century.

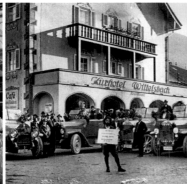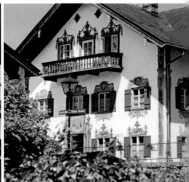

Nestled among the Ammergau Alps, whose pristine nature is part of Bavaria's largest nature preserve, Oberammergau offers a broad pallet of leisure-time and recreational activities in both summer and winter. Combining tourism and conservation sensibly is of particular concern to the people of Oberammergau.

Parish priest Joseph Alois Daisenberger, who worked not only as pastor and historian in Oberammergau, but also as director and editor of the Passion plays, realized the unique potential of this village early on and enthusiastically lent it expression in the closing words of his famous inaugural sermon in Oberammergau on 13 July 1845:

"Life here is good! Couldn't it almost be a paradise? A heaven on Earth? Could our Oberammergau itself become such a place? Let us make it so!"

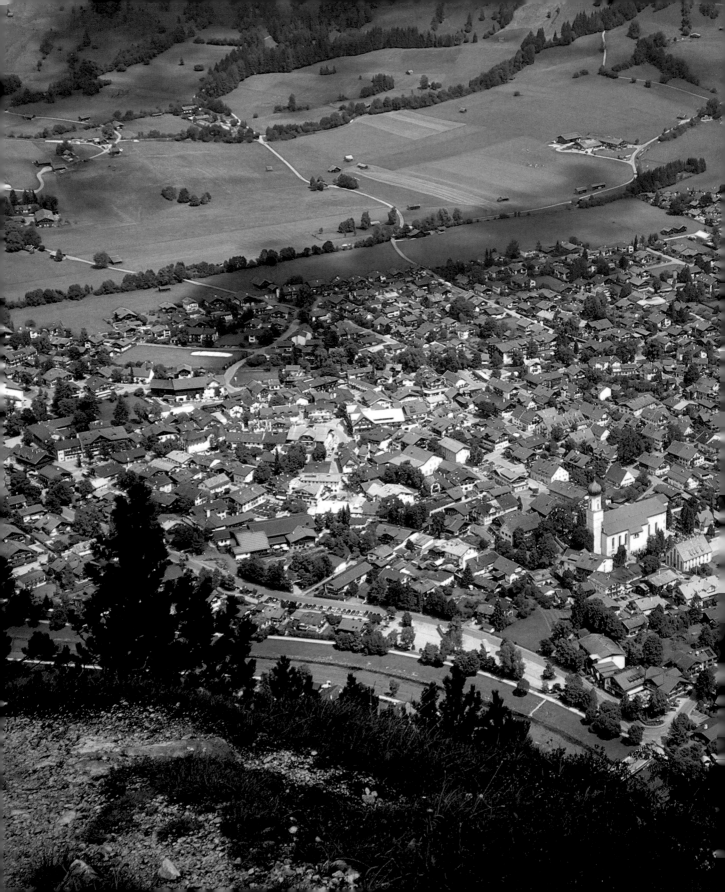

The Village and Its History

"Many of them had really looked around the world and learned to appreciate the value of sound education, but each one was only happy again when he returned home and was seated comfortably at the foot of Mount Kofel by the river Amper."

From Ludwig Thoma's *Erinnerungen* (Reminiscences) of 1919 about his birthplace, Oberammergau

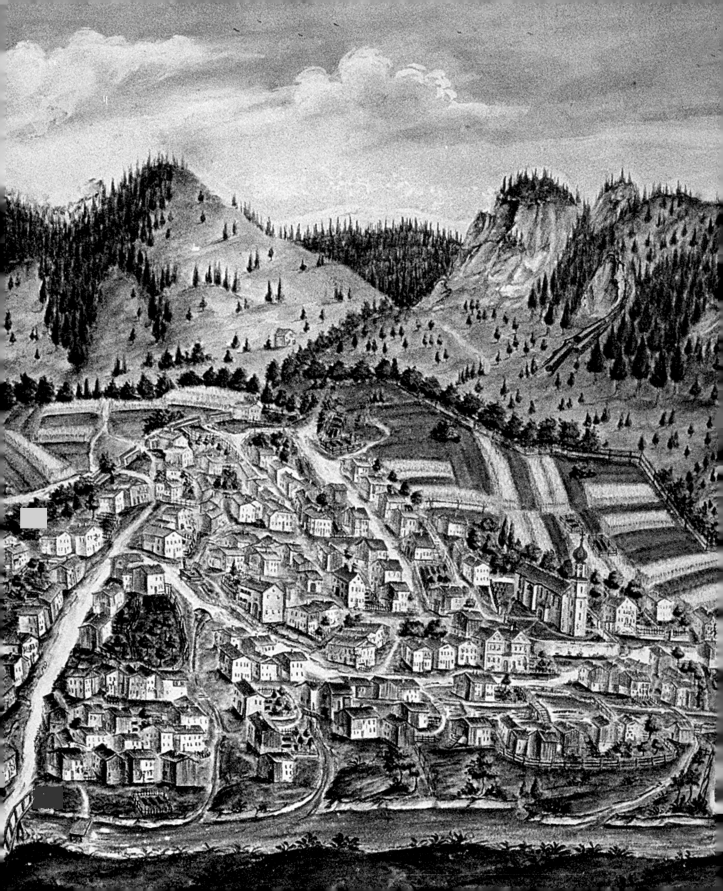

Previous double page: View of Oberammergau from Mount Kofel

Left: *The Village of Oberammergau* by Joseph Bierling, 1925

"Welcome to Oberammergau: Come unto me, all ye that labor and are heavy laden! I will give you rest."

Cover drawing by Karl Arnold for *Simplicissimus*, 29 March 1922

Servus from Oberammergau

The town of Oberammergau lies in Bavaria's largest nature preserve, the Ammergau Alps. It is not only world famous as the site of the Passion play and a center of handicraft production, but has also made a name for itself as a climatic health resort and vacation paradise. Flanked by its two local mountains, the Kofel and the Laber, the village lies at an altitude of about 2,953 feet (900 meters) above sea level on the alpine river Ammer. With its approximately 5,300 inhabitants, Oberammergau is the largest community of the Ammer Valley and part of the region of Werdenfelser Land.

Candor, Wits, and Liveliness

"The entire population is devoted to the Catholic religion [in the meantime around twenty percent of the town's inhabitants are Protestant]. Some of the families are old Bavarian families, others come originally from Swabia or Tyrol ... The merging of these three nationalities is also imprinted upon the character of Ammergau's inhabitants. Most of them combine the straightforwardness and candor of the Bavarian with the wits and cleverness of the Tyrolean and the cheerful and merry tendency, liveliness, and loquaciousness of the Swabain."

From *Geschichte des Dorfes Oberammergau* (History of the village of Oberammergau) by Joseph Alois Daisenberger, from 1859–61

OBERAMMERGAU

Oberammergau's coat of arms—given to the community in 1959—recalls the vow taken by the inhabitants in the plague year 1633 to perform a play of the "Passion, death, and Resurrection of our Lord Jesus Christ" every ten years.

Time Travel: From Cult Site to the Present

Archeological excavations, houses with *Lüftlmalereien* or façade paintings, the Passion plays, art workshops, natural settings steeped in legend and living customs—the history of Oberammergau is not only exciting and complex, it is also tangible on every street corner. Already from a very early date, Oberammergau forged connections throughout the world, and even today still knows how to combine tradition with open-mindedness.

History Made Tangible: The Oberammergau Puzzle Path

Along the enchantingly beautiful Oberammergau Rätselweg, or Puzzle Path, which starts at the south of the new cemetery at the foot of Mount Kofel, it is possible to literally "grasp" the early history of Oberammergau. The path leads not only to one of the main finding places of the Celtic sacrificial site at Döttenbichl but also to the Marian grotto, the Malenstein next to its cave, and to several rock faces with puzzling petroglyphs from various centuries. A tour by the knowledgeable local nature guide offers not only a great deal of information but also wonderful narrations of the region's legends and myths.

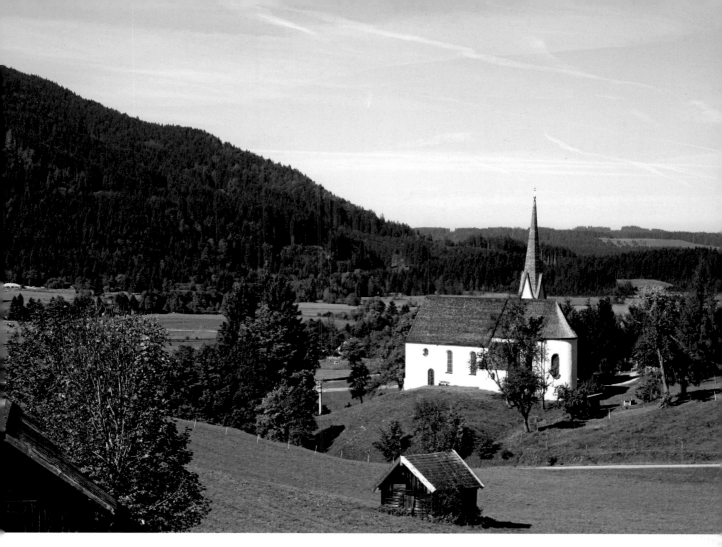

The pilgrimage church Heilig Blut, known to the locals as the "Kappel," is located on the spot considered to be the oldest prayer site in the Ammer Valley; it was built around 1090 on a small hill about a twenty-minute walk north of Unterammergau. The Welf prince Eticho is said to have retreated here around the year 900 with some of his loyal followers in order to live as a recluse and found a community of monks.

Just as dramatic today as 2000 years ago: The *Föhn* wind comes to the Ammergau Alps.

The Celts in Oberammergau

"... but it is indeed probable that even back then a horde of Celtic tribes had settled there ..."

What the parish priest Joseph Alois Daisenberger had hypothesized in his book *Geschichte des Dorfes Oberammergau* (History of the village of Oberammergau) written between 1859 and 1861, became certain in the 1990s due to a sensational, chance archeological find at Döttenbichl near Oberammergau. Researchers there uncovered a Celtic cult site, indicating that the Ammer Valley was settled long before its conquest by the Romans. In the period between 100 BC and AD 50 numerous offerings were sacrificed at Döttenbichl: in addition to Celtic fibulae for clothing, there were tools, coins, and many used Roman weapons, which point to hostile encounters between the locals and the Romans. Three Roman catapult bolts bear the stamp of the nineteenth legion, which was devastatingly defeated in the year 9 BC in the Battle of the Teutoburg Forest and never again raised. The over 700 pieces of metal discovered at Döttenbichl derive from the time of the Roman Alpine campaign under Emperor Augustus in the year 15 BC. They are the oldest known Roman finds in Bavaria.

The Village in the Middle Ages

Ammergau, first mentioned in the documents as a region in the ninth century and as a town in 1150, was in the possession of Europe's oldest princely house, the House of Welf, until the beginning of the twelfth century. In 1192 the Swabian noble family of the House of Hohenstaufen took over the area, and in 1269 the Ammergau region passed into the possession of the Bavarian House of Wittlesbach.

When Duke Welf I founded the Rottenbuch chapter of Augustine canons in 1073, they provided pastoral care for the entire Ammer Valley. Since the twelfth century, Oberammergau has had its own parish, which stood under the spiritual patronage of the Rottenbuch monastery until secularization in 1803. On the site of the present Catholic parish church of Saints Peter and Paul in Oberammergau a small wooden church was built first, later to be replaced by a Romanesque stone church, which ultimately made way for a Gothic building. As the Gothic building became

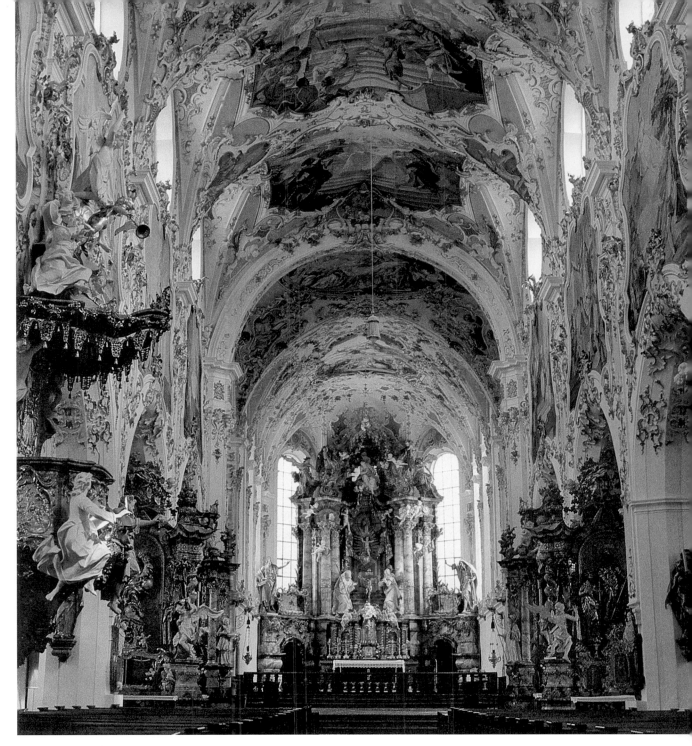

The Rottenbuch collegiate church. The originally Romanesque basilica was expanded in Gothic style and decorated in rococo style in the middle of the eighteenth century by the Wessobrunn stuccoist Joseph Schmuzer. The frescos of the interior decoration comprise some of the most outstanding works by Matthäus Günther, whose work can also be found in the Oberammergau parish church of Saints Peter and Paul. In the wake of secularization Rottenbuch monastery was dissolved in 1803. Since 1963 the former chapter of Augustinian canons has served as a convent for the Salesian Sisters of St. John Bosco.

Saints Peter and Paul: One of the Most Beautiful Village Churches in Upper Bavaria

In addition to the ceiling paintings, statues, and frescos by famous artists such as Matthäus Günther, Franz Xaver Schmädl, Johann Jakob Zeiller, and the "Lüftlmaler" or façade painter Franz Seraph Zwinck, something else awaits discovery in the parish church of Saints Peter and Paul: In the middle of the right side altar, the altar of the cross, can be found—according to tradition—the very cross before which the people of Oberammergau vowed to perform the play of the Passion, death, and Resurrection of Christ every ten years.

dilapidated, a new rococo structure was begun between 1736 and 1742 under the direction of Joseph Schmuzer. Schmuzer, who was assisted in the work by his son Franz Xaver, came from one of the most famous family dynasties of stuccoists and master builders from Wessobrunn, one of the most important centers of stucco work in Europe between 1600 and 1800.

The Abbey of Ettal: In the Name of the Benedictines

In 1330 Emperor Ludwig the Bavarian founded the Abbey of Ettal, after Rottenbuch the second most important abbey that had an influence on Oberammergau from the high Middle Ages to the beginning of the nineteenth century. While Rottenbuch held spiritual authority over the Ammergau region, secular jurisdiction lay in the hands of the Benedictines at Ettal. The farmers of Ammergau had to pay annual dues to the abbey, but a few days before the ground-breaking at Ettal they received an imperial attest of their rights of freedom and inheritance.

"... it is out of special favor to the peasantry of Oberammergau, that We desire that they have the right to inherit and build upon the properties that lie in the Ammergau, whether this be farm or 'hide'..."

Document of 23 April 1330

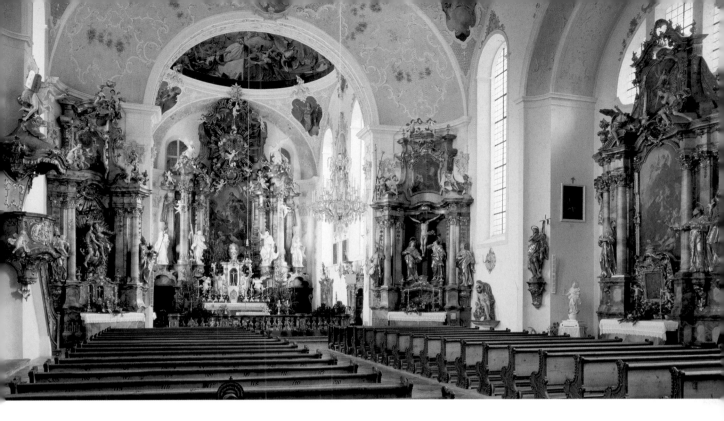

The Horizon Broadens: The Long-Distance Trade Road, Oberammergau's Door to the World

Oberammergau's position on the long-distance trade road from Venice to Augsburg, dating from the Roman period, brought advantages to the village in many ways: The "staple" or "stacking" right granted by Emperor Ludwig the Bavarian in 1332 guaranteed the inhabitants of Ammergau a lucrative source of income: Among other things, all tradesmen traveling along the trade road were required to pay for the temporary storage of their wares and to offer them for sale to the local inhabitants. Ammergau carters then transported the wares to the next transport station in Partenkirchen.

Also the development of Oberammergau woodcarving, which began in the early sixteenth century, was furthered by the many contacts with tradesmen from northern Italy and southern Germany: On the one hand they represented potential clients and carriers, and on the other hand, they functioned as ambassadors of the various styles and ideas of other cultures.

The parish church of Saints Peter and Paul with a view of the high altar. Like all the other altars in the church, the high altar, too, was created by Franz Xaver Schmädl. The altarpiece is by Matthäus Günther.

The Carters

Transport by wagoners or carters was an important economic factor in Ammergau until about the middle of the seventeenth century, after which it finally declined in importance in the late eighteenth century. Not only the street names (Rottstraße and Warbergstraße) in Oberammergau, but also a bronze monument in front of the Oberammergau museum, which depicts a transit wagon, recall this tradition.

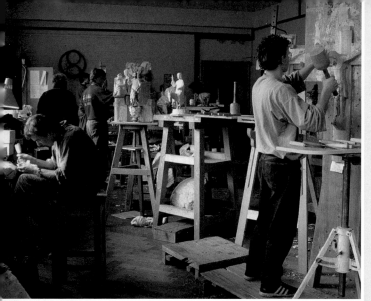

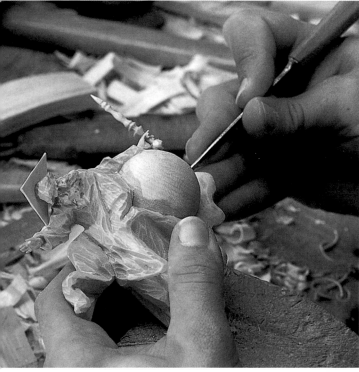

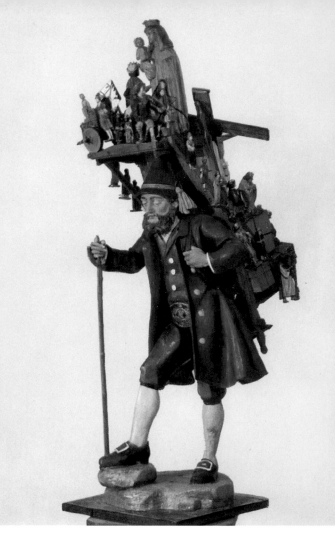

Upper left: Woodcarving students at work

Lower left: The art of Oberammergau's carvers ranges from filigree figures only an inch or two high to sculptures several feet high and church altars.

Right: The *Kraxnträger*, or pack-bearer, designed and executed by Anton Killer, stands in front of the company Georg Lang sel. Erben.

The Art of Woodcarving is Born

The first written accounts of the Oberammergau carvers' great skill appear at the beginning of the sixteenth century. But given that a fair amount of practice is required to attain such skill with a woodcarving knife, historians assume that woodcarving had already begun in Oberammergau in the late Middle Ages. In the sixteenth century it developed into a significant source of secondary income in the town. The difficult climatic conditions for agriculture combined with the population growth, on the one hand, and, on the other, the abundance of wood and the good transportation and sales opportunities supplied by the trade road might have contributed to this development; so too, perhaps, did the proximity of the Abbey of Ettal, which, as a heavily visited

"Please send me money so I can still be funny..."

That the woodcarving merchant Georg Lang always kept his sense of humor can also be seen in this sentence, with which he ended many a letter to business partners in arrears.

The company in a photo from around 1905. Here, incidentally, the poet Ludwig Thoma was also born, on 21 January 1867. His mother was visiting her sister Marie Lang in Oberammergau, awaiting the birth of her child here (see p. 122).

pilgrimage site, had a large need for devotional objects, crucifixes, and small mementos. In 1682 woodcarving was declared a free trade in Oberammergau, and in the early eighteenth century the painting of woodcarvings was introduced as a branch of the trade. At first, the trade in carved wooden works was more or less regional: So-called *Kraxnträger*, or pack-bearers, traveled throughout the countryside with their wares and sold the works, which had been produced in a kind of cottage industry. In 1775 the woodcarver and glass and façade painter Georg Lang founded a business that soon began exporting Oberammergau woodcarvings throughout the world, and in the course of the nineteenth century became the town's most important employer. Even today, under the name of Georg Lang sel. Erben, the firm remains a flourishing business, led by one of the founder's descendents.

The First Craft Ordinance

In addition to the renewed confirmation of the farmers' right to freedom and inheritance, from the period of the sixteenth century the town chronicle also reports of the first Craft Ordinance, issued in 1563 by the Abbot Placidus of the Abbey of Ettal. This had become necessary when two men who had not been trained within the craft wanted to practice woodcarving. The Craft Ordinance protected old, established woodcarving families from the influx of outsiders; additionally, only their legitimate children were in turn allowed to become woodcarvers. Other arts developed in Oberammergau in addition to woodcarving—although contemporaries referred to their practitioners not as artisans, but simply as craftsmen or workers—including the art of verre églomisé, or reverse painting on glass. In the sixteenth century, this art was still the preserve of the emperor, nobility, and clergy, but by the eighteenth it began to be found in folk art (see p. 81).

On the Hintere Hörnle

The Little Men from Venice

In the fifteenth and sixteenth centuries, the renowned glass factories on the island of Murano near Venice sent their prospectors into the Alpine regions to look for minerals there, especially gold. The legendary little men from Venice were in Oberammergau and Unterammergau as well, and many stories about them still circulate even today. With the help of a "mountain mirror," reverently called a "magic mirror" by the locals, they were able to find the mountains' hidden treasures. The often rather short foreigners, who traveled with their donkeys through the Alps early in the year and returned home in the fall loaded with treasure, were very uncanny to the town's inhabitants, who thought they must have made a pact with the devil. The precise location of some of their excavations, called *Gufllöcher*, is widely known, such as the treasure hole on Mount Hörnle at Bad Kohlgrub, but there are also sites that even today remain the well-kept secret of the locals.

The First Local Council

Since around 1600 Oberammergau has been administered by the so-called Six or Twelve, who were newly elected annually and were subordinate to the judge of the Abbey of Ettal. The Six were a kind of parish council who oversaw the accounting, supervised the community work, and arranged for schoolmasters, town criers, and shepherds. The Twelve were called in as representatives of the parish community to advise the Six in important matters. These "superiors of the parish community" as parish priest Daisenberger referred to them in his town chronicle mentioned above, assembled together in the decisive year 1633 as the plague arrived at Oberammergau (see p.51).

... And then Came the Black Death: The Plague Vow and the Beginning of the Passion Plays

The Thirty Years' War (1618–48) brought not only hunger and death to Europe—in Germany alone it decimated the population, reducing it from 17 to 4 million—but also scourges like smallpox and the plague, the particularly feared Black Death.

In 1632 bands of Swedish soldiers came plundering and murdering as far as Ettal, and with them came the plague, which began to spread rapidly in the region of Werdenfelser Land. Throughout the region plague fires, visible from afar, burned as a sign that a town had been visited by the plague. Oberammergau's neighboring communities of Eschenlohe and Kohlgrub were visited by the epidemic. Thanks to strict watches posted at the edge of town, Oberammergau had remained largely spared, but this changed in the fall of 1632: The day laborer Kaspar Schisler, who had been working for two years as a summer reaper in Eschenlohe, slipped by the plague watch to celebrate the fair in Oberammergau with his wife and children—and brought the plague into the village. By the end of October 1633, of the estimated 800 inhabitants, 84 adults and several children (the number was not recorded in the parish register) had died. The same year, in the cemetery of the parish church of Saints Peter and Paul, village representatives vowed to perform a Passion play every ten years in hopes that the town would be freed from the plague. According to the surviving sources,

In the year before the Passion plays the play *The Plague* is always performed in the Passion theater. This play explains how the plague vow came about. Scenes from the 2009 performance:

Right: Kaspar Schisler (Anton Burkhart) visits his family in Oberammergau during the annual fair.

Below: The plague claims its first victim: the gravedigger Faistenmantel (Frederik Mayet) buries Schisler's small son (Vitus Norz).

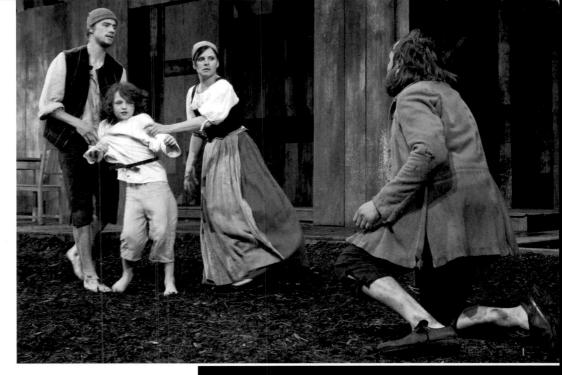

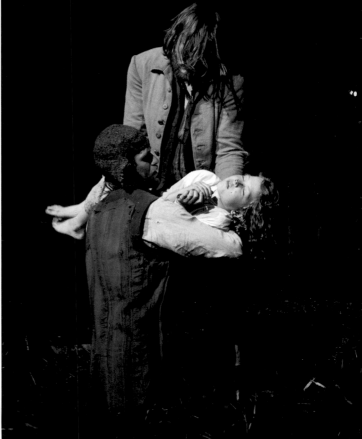

from this moment onwards there were no more deaths of plague to mourn in Oberammergau, even though the scourge continued to wreak havoc in Bavaria.

In 1634 the people of Oberammergau constructed a stage in the cemetery, upon which the "Play of the Passion, Death, and Resurrection of Our Lord Jesus Christ" was performed for the first time on Pentecost. Almost two hundred years later the stage would be erected on a field at the northwestern edge of the town, where the Passion theater still stands today (see p. 53).

The history of the Passion plays is marked by the great community spirit and absolute determination of the people of Oberammergau to keep their vow despite all the adversities that have threatened the performances again and again over the centuries. "The Passion," as the people of Oberammergau call their Passion plays, is seen today by around 500,000 visitors from all over the world in over 100 performances. Half of all the town's inhabitants collaborate either behind or on the stage, provided that they were born in Oberammergau or have lived here for at least twenty years.

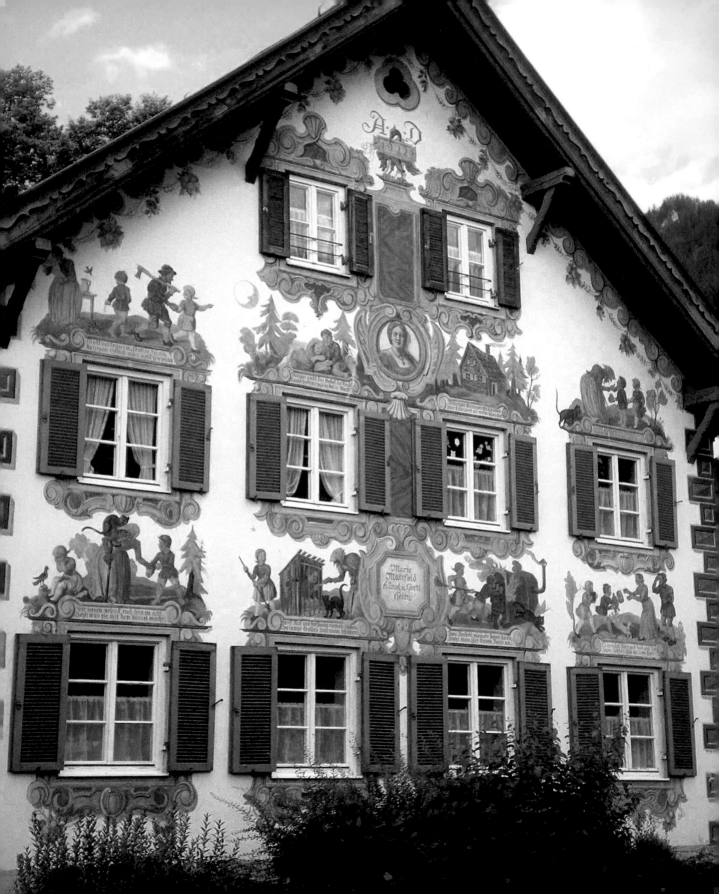

Left: The fairy-tale frescos of this children's home, built in 1922, gave it its original name, "The Hansel and Gretel Home." On its façade the entire story of the Grimms' fairy tale "Hansel and Gretel" is depicted as well as individual scenes from "Little Red Riding Hood" and "The Wolf and the Seven Young Kids." The official name of the children's home is the Marie Mattfeld House, after its donor, a German-born opera singer, who lived in the USA in the 1920s.

Fall and *Winter*, two examples of secular illusionistic painting, adorn the rear façade of the forestry house; they were painted by the famous Lüftl painter Franz Seraph Zwinck.

Early Networking throughout the World

In the beginning of the eighteenth century, global trade boomed. The businessman's sights were set even across the Atlantic, and transformed Europe's ports into lucrative places. Oberammergau merchants founded business branches for their locally produced woodcarvings above all in northern and northeastern Europe: in Hamburg, Lübeck, Bremen, Amsterdam, Copenhagen, Oslo, Göteborg, Königsberg, in Russia, Poland, and the Baltic. But the able businessmen of Oberammergau were also drawn southwards, to Spain. The entire town profited from this development, not only economically but also non-materially: After a few years, tradesmen from Oberammergau with their own firms would often summon their sons to take over the business and themselves return home—bringing with them their experiences, ideas, and global contacts. In addition to the ever-increasing number of visitors appearing at the Passion plays—in 1760 there were already around 14,000 viewers—it was the woodcarving trade that brought the world to Oberammergau.

But life in the village remained hard: Cattle plagues, fires, cold winters, debts from the performances of the Passion plays, threats from war, floods, plagues of mice, and even two earthquakes afflicted the people of Oberammergau.

Houses that tell Stories: *Lüftlmalerei*

In the eighteenth century a handicraft developed in Oberammergau that has given the town an incomparable atmosphere: *Lüftlmalerei*, or façade painting. The walls of the houses, adorned with frescoes painted in perspective, depict various motifs, from Biblical representations through stories of the village from the *Village and House Chronicle* to motifs from fairy tales. On many houses a small plaque has been mounted with information about the particular painted house's history. The most famous of the façade painters in Oberammergau and the surrounding area is Franz Seraph Zwinck (1748–1792); his most famous façade painting is at the Pilatushaus or Pilate House in Oberammergau (see p. 84). But also the Judas House, the oldest house in town, the Kölbl House, which can still be admired in its original

The Pilate House

The Pilate House, built in 1774, was acquired by the merchant Anton Lang in 1784 and in the same year decorated with beautiful façade paintings by Franz Seraph Zwinck. The house's name comes from the fresco *Pontius Pilate's Judgment of Jesus*, which can be seen on the façade facing the garden. The Pilate House has been owned by the community since 1969 and was laboriously renovated between 1982 and 1986. Today, with its "living workshop" and collection of verre églomisé paintings the Pilate House is not only a center of arts and crafts (see p. 74), but also houses the civil registry office: a real insider's tip, with its charming wedding room full of character and its baroque garden.

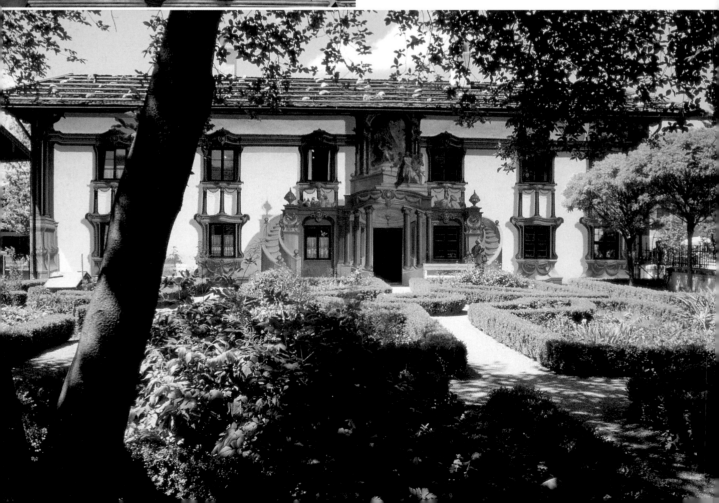

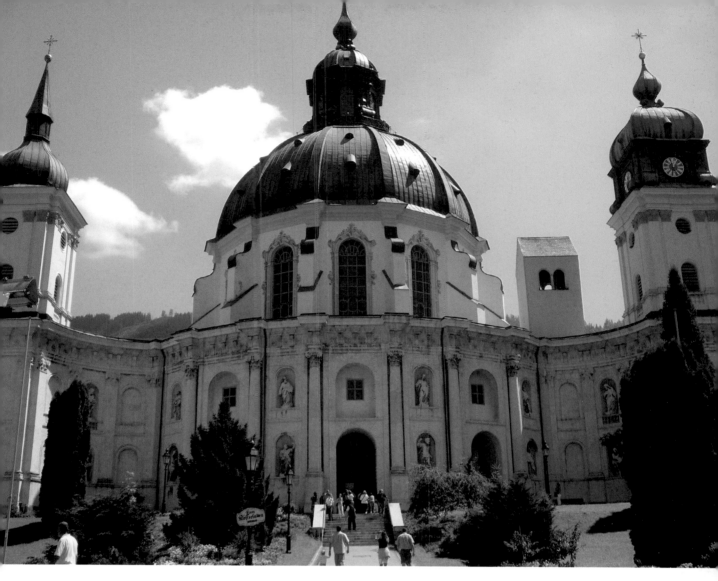

For centuries, the Benedictines of Ettal Abbey had temporal jurisdiction over Oberammergau, until secularization in 1803.

condition, and the present-day State Forestry Office are three of many examples of his magnificent artisanship.

The Kingdom of Bavaria

The consequences of Bavaria's shifting military alliances during the Napoleonic period at the beginning of the nineteenth century could also be felt in Oberammergau: Whereas in 1800 the town had been plundered by the French, six years later Napoleon elevated Bavaria to a king-

dom as a reward for its loyalty to the alliance. In Oberammergau this was celebrated with a church service, a ringing of bells, and a gun salute. In 1812 French and Bavarian soldiers marched side by side to their destruction in Napoleon's Russian campaign, among them fourteen from Oberammergau, of whom only three returned home. In the following years Bavaria changed sides to ally with Napoleon's opponents, and when the Napoleonic wars finally ended in 1815, special performances of the Passion

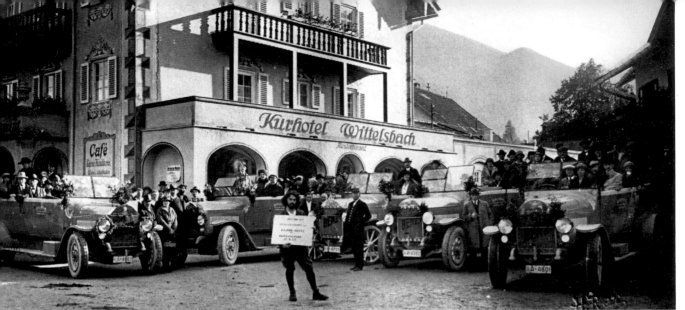

Passion guests with their automobiles in front of the Kurhotel
Wittelsbach, 1922

were staged in thanks in Oberammergau, intended also to
refill the empty community coffers.

In the meantime the abbeys of Ettal and Rothenbuch were
expropriated in the secularization carried out in 1803, thus
losing their political and spiritual influence over Oberam-
mergau. This marked the end of a centuries-long, close rela-
tionship between the village and its two neighboring abbeys,
which had had such a strong influence on the region. Within
the community as well, political changes took place as a result
of reforms carried out by Count Montgelas: Robbed first of
their self-determination, only after the fall of Montgelas in
1818, was a certain right to self-government ceded to the com-
munity again, including the free choice of a mayor.

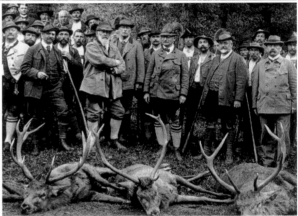

Prince Regent Luitpold, surrounded by his hunting party after
a successful deer hunt, 1910

Great Ladies and Gentlemen Frequent the Town …

In addition to many visitors from all over the world—in
1860 there were already around 100,000—the European
high nobility and the Bavarian kings also came regularly to
Oberammergau. From the time of King Ludwig I, a visit to
the Passion plays by the Bavarian rulers and their relatives
came to be taken for granted. But even outside of the Pas-
sion play season there were occasional personal contacts
between the town's inhabitants and their ruling house. The
royal hunting parties on Mount Kofel and its surroundings
as well as the construction of Linderhof Palace, on which
many inhabitants of Oberammergau worked, and not least
the handicrafts, which were supported by the monarchs
through their interest and financial donations, contributed
to the close relationship between the people of Ober-
ammergau and the Wittelsbachs. One particularly fre-
quent guest was King Ludwig II. In his honor a separate

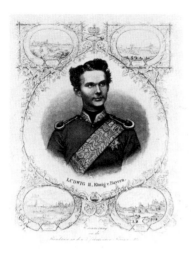

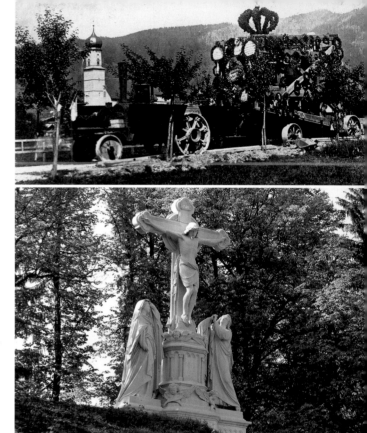

"... nowhere, it appears, is there poverty. Many houses, whitewashed, bear painted decoration [*Lüftlmalerei*]... Great ladies and gentlemen frequent the town, among them today: her royal highness Princess Luise of Prussia, incognito, with her two daughters, royal courier, and maid-in-waiting ... English, French, Americans, Christians, heathens, and Jews paint a colorful picture. Hundreds of carriages and wagons forge their way through the crowd. Everything revolves around the questions of the day: a ticket and a place to stay."

From the travel diary *Einmal Oberammergau und zurück* (Once to Oberammergau and back) by the farmer Matthäus Storath, kept in the Passion year 1890

The Crucifixion Group: King Ludwig II's Monumental Gift

Transporting the over-thirty-five-foot-high marble monument along the Kienbergstraße and up Mount Ettal proved to be difficult. A steam tractor, which had never been seen before, and had just passed its very first vehicle inspection, was able to pull the Cross and its pedestal only partially up the mountain: The eighty-man-strong Oberammergau fire department had to help with block and tackle. During transport of the figure of John a tragic accident occurred in which both the master stonemason Franz Xaver Hauser and his apprentice Kofelenz lost their lives. Between 1878 and 1883 King Ludwig II traveled every year on the birthday of his mother to Osterbichl to pray before the monument. Even today this place is not only a favorite goal for hikers, but is also linked through Masses to the church life of Oberammergau.

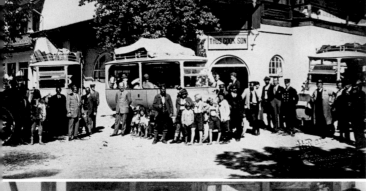

Passion guests in front of the office of Thomas Cook on Dorfstraße, 1922

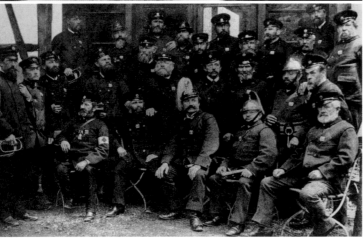

Only adult men with impeccable reputations and physical fitness were accepted: the volunteer fire department on the twenty-fifth anniversary of its founding, on 5 May 1895.

performance of the Passion was given in 1871, which deeply impressed him. In gratitude he gave the people of Oberammergau a great monument representing the scene of the Crucifixion with Mary and the disciple John, created by the Munich sculptor Johann von Halbig. On 15 October 1875, the fiftieth birthday of the king's mother Marie, the Crucifixion group was unveiled upon the Osterbichl, a small hill above the town. The site was chosen by Ludwig himself.

Hot Spot Oberammergau

The steadily increasing stream of visitors during the Passion play season and the growth in tourism from the middle of the nineteenth century—the world's leading travel organizer Thomas Cook added Oberammergau into his program in 1880—had a positive effect on the town's development. But they also presented it with serious organizational, infrastructural, and financial problems: Sufficient accommodations and guesthouses were needed, the approach routes had to be adequately ex-

panded, the Passion theater had to be accommodated to increasing needs. The town invested in a new hospital, modernized the water supply, founded a volunteer fire department, and made provisions for the repeated flooding catastrophes. While the railway connection between Oberammergau and Murnau was not exactly promoted by the people of Oberammergau, once it was completed in 1900 they quickly reconciled themselves to this innovation that was greeted with such joy by the Passion guests and the summer vacationers.

At the end of the nineteenth and beginning of the twentieth centuries Oberammergau witnessed the founding of numerous societies that contributed significantly to the area's cultural diversity. Among these were the musical society, the gymnastics and sports club, the beautification and tourism society, the reading society, the society for traditional folk costumes, as well as organizations engaged in social causes. As early as 1836 there was the St.-Lukas-Verein, or Society of Saint Luke, which saw its mission originally as the support of needy

The forty-seven performances of the Passion play in 1900 were visited by 174,000 guests from Germany and abroad.

Prominent persons in front of the entrance to the Oberammergau Museum on 11 August 1921. From left to right: the Bavarian minister president Gustav von Kahr, Munich police president Ernst Pöhner, the deputy mayor of Oberammergau Sebastian Schauer, director of the woodcarving school Ludwig Lang, and the founder of the museum, Guido Lang

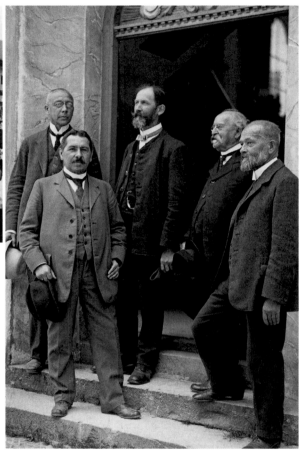

artists and woodcarvers, and even today continues its engagement on their behalf. Drawing courses have been held since the early nineteenth century for the promotion and training of woodcarvers; in 1877 these opened in the newly founded woodcarving school. There, woodcarvers are still trained today to a high standard and can end their training after three years with a test that is the equivalent to a diploma of apprenticeship (see p. 80).

A Folk Art Carves out a Career for Itself

In 1902 the Verein für Volkskunst und Volkskunde (Society for Folk Art and Folklore) was called into existence in Munich, mostly by architects and sculptors with the goal of "awakening vernacular domestic arts." Among the founding members were also Oberammergau's Guido Lang, owner of the woodcarving firm Georg Lang sel. Erben, and the Munich architect Franz Zell. The latter was commissioned in 1904 by Guido Lang to build a museum in Oberammergau dedicated primarily to woodcarving and the domestic arts. The founding of a museum by a private individual such as Guido Lang was an absolute exception at the time: Lang not only had the museum constructed specifically, but also financed it himself.

Franz Zell (1866–1961) planned and built not only the Oberammergau Museum but also the woodcarving school. His deep commitment to folk art as well as his desire for integrating his architecture into the surrounding location represented a great stroke of luck for the town.

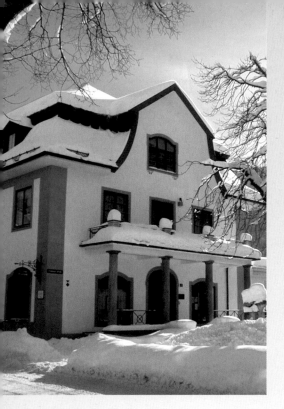

The museum promises an exciting journey of discovery through five centuries of the art of woodcarving, guaranteed to delight children.

Lower left: A great number and variety of wooden toys are also carved in the "village of crucifix carvers," as can be seen in the exhibition *Stecken-gaukler & Co.* on the first floor.

Lower right: The historic Oberammergau church crèche with the Wedding at Cana

A Cultural Beacon: The Oberammergau Museum

"The collection is meant to be a lasting monument to Oberammergau's ceaseless striving and feeling for art as well as an enticement for the youth to equal their elders."

Guido Lang in a letter of 14 October 1914 to Oberammergau's municipal administration on his motives for erecting the museum.

It is hard to overlook: In the middle of town, right on Dorfstraße, stands the imposing building of the Oberammergau Museum, a jewel both inside and out. Commissioned in 1904 by Guido Lang from the Munich architect Franz Zell, it was opened in 1910 under the name Verleger Lang'sches kunst- und kulturgeschichtliches Oberammergauer Museum (Merchant Lang's Art and Cultural Historical Oberammergau Museum). Then as now the main focus of the collection is woodcarving, which meanwhile can look back upon a 500-year-old tradition in Oberammergau. Since 1953 the museum has been owned by the community and a few years ago was thoroughly restored and conceptually remodeled with a great deal of knowledge, enthusiasm, and imagination. Interactive elements, temporary special exhibitions, and an educational program for children link the traditional theme of the art of woodcarving with the modern world. The extensive collection not only displays works from around five centuries, but also shows how the local art history and social history are reflected in the art of woodcarving (see p. 75–79).

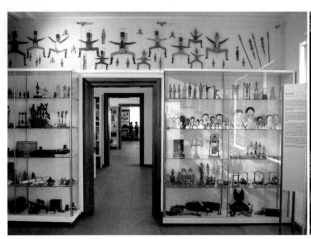

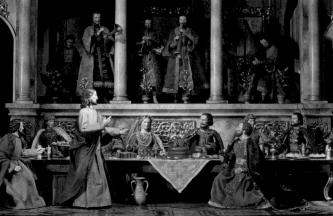

"The year 1914 brought us many guests, also from other countries, who, however, left Oberammergau in droves at the beginning of August as soon as war broke out."

Aus meinem Leben (From my life, 1930) by Anton Lang, the most well-known actor playing Jesus in 1900, 1910, and 1922

The merchant of woodcarvings and museum founder Guido Lang with his daughter Hertha, 1904

Oberammergau Pays a Visit to Washington

The economic and social consequences of the First World War (1914–18) could also be felt in Oberammergau, directly and with unexpected intensity: Many men fell in the fighting or were taken prisoners of war; in the village there were severe shortages of food, resulting, incidentally, in a drastic increase in wildlife poaching; there was no work, and most of the guests failed to appear. Even while the war still raged plans were drawn up for a home where orphans from throughout Germany could be cared for. But the "Hansel and Gretel Home" could only be realized in 1922 after a generous contribution by the German-American Marie Mattfeld, and today provides a home for around fifty children with serious family troubles.

The Passion play planned for 1920 had to be rescheduled for 1922 due to the difficult transportation and food situation. This year was chosen because it was hoped that the German Trade Show, which was taking place concurrently in Munich, would draw more visitors to Oberammergau. Despite a record number of visitors—around 310,000—the financial situation in Oberammergau in the inflationary year 1923 was nonetheless catastrophic. There was neither money nor work for the roughly one hundred woodcarvers in town. Despite severe hardship, the community flatly rejected a US offer to film the Passion plays, with good reason. Instead, they chose another way to improve their financial situation: Equipped with woodcarvings and other works of craftsmanship, a fourteen-person

A scene from "Little Red Riding Hood" on the Hansel and Gretel Home

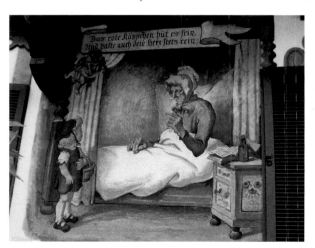

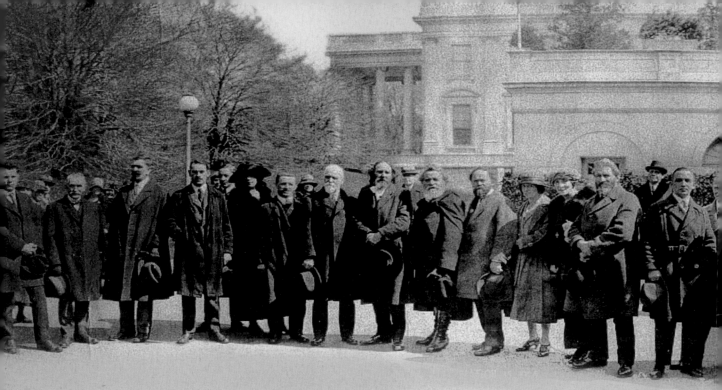

Participants on the America trip in front of the White House,
15 March 1924

Departure from America in May 1924

Oberammergau delegation under the direction of Anton Lang made its way to the US in 1923 in order to take part in sales exhibitions in American cities. The six-month trip to America, which became a successful promotional tour for Oberammergau's works of craftsmanship, also led the group to Washington, where they were received by the American president.

Anton Lang's optimistic estimation of how orders for woodcarvings would develop would not prove completely accurate. There was some work, but the woodcarvers' situation remained critical. In addition to the global economic situation was the fact that Oberammergau's domestic arts were being increasingly copied by machine and sold as originals. As a result, in 1928, the Society of Saint Luke had a trademark registered for its woodcarvings; it is still used today.

In the 1920s long overdue investments were made in Oberammergau: A home for the elderly was built; the town received its own post office, a Protestant church, a gymnasium, and finally a waste removal system that

Jesus Crosses the Hudson

"...the next morning we already found ourselves on the Hudson River ... at eight o'clock a steamboat with music and committee members appeared to greet us, the visitors from Oberammergau. Fifty journalists and photographers came on board and began to photograph, film, and interview us ... From New York I paid a visit to Thomas Edison, the great inventor ... The old and honorable Mr. Edison received me and Petrus very affably and told us that he had seen the Passion play in Oberammergau already in 1890 ... Mr. Niffen brought us to the White House, where we were all introduced to President Coolidge. The president shook everyone's hand, spoke a few words ... and wished us much success with our exhibition ... With grateful hearts we started homeward on 15 May, after a six-month stay in America. We were able to bring home two years' worth of work ... Our woodcarvers were working; they delivered altars and furniture, religious and secular woodcarvings to America."

Aus meinem Leben (From my life, 1930) by Anton Lang

Zeppelin over the post office, 23 September 1930

regularly collected household refuse, following the example of large cities like Munich.

Oberammergau during the Third Reich

Although a regional group of the NSDAP, or Nazi Party, was founded in Oberammergau in 1929, until 1933 the party played only a minor role. The citizens and the local council tended to take a rather negative view of it, and when, in 1930, Adolf Hitler and Joseph Goebbels were among the visitors to the Passion plays, they received less attention than the America automobile manufacturer Henry Ford. But this changed after the seizure of power in 1933. Only a few days afterwards, on the command of the Reichskommissar of Bavaria, flags with swastikas were flown on all public buildings in Oberammergau as well. Hitler visited the jubilee Passion plays in 1934 to exploit

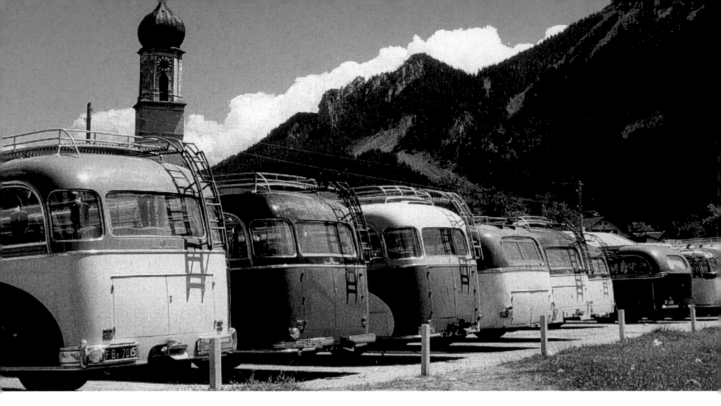

Almost half a million visitors came to Oberammergau in 1950 to the Passion plays, many with organized bus tours.

them for one of his staged, propagandistic entrances. The plays were declared matters of "importance to the Reich" and in part ideologically appropriated by those in power.

Between 1934 and 1939, in the wake of National Socialism's employment policy, several construction plans were realized in Oberammergau: The further regulation of the Ammer River, the building of housing, a new schoolhouse, the Saint Gregory Alpine pool, and—not approved by the people of Oberammergau—an army barracks for 800 Wehrmacht soldiers at the foot of Mount Laber. Today this site contains the Bundeswehrverwaltungsschule (Armed Forces Administration Institute) and the NATO school.

Due to the outbreak of World War Two (1939–45) the 1940 Passion play had to be cancelled, since most of the musicians and actors had received conscription orders. Despite this, there were soon no free beds to be found in Oberammergau: Instead of Passion visitors and tourists now it was people from areas in danger of being bombed who flocked to the town. Many of them had to leave when, in

1943, the aircraft manufacturer Messerschmitt AG moved part of its arms production to Oberammergau and housed its senior staff in town. Half of the workers were forced laborers who lived in barracks in Camp Rainenbichl. On 29 April the Americans finally arrived in Oberammergau. The deputy mayor Alfred Bierling approached to inform them that the town was free of the military: The war was over for Oberammergau. The town had 119 soldiers killed in action to mourn, 17 Oberammergau soldiers died of their wounds shortly after the war's end, 54 remained missing, and 93 had been taken prisoners of war.

The Peace Plays

In the years following the war tourism lay fallow, not only in Oberammergau. And so it was with even greater expectations that the people of Oberammergau anticipated the Passion play year of 1950, declared a Christian Jubilee year by Pope Pius XII. It was anticipated, with good reason, that visitors from overseas would combine a trip to Rome with one to Oberammergau. The "Peace

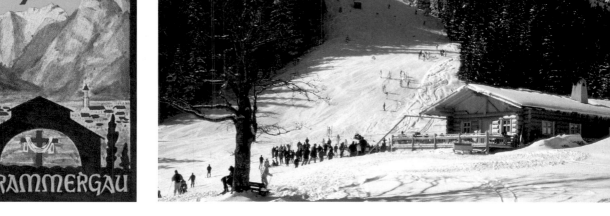

Luggage tag for the Passion plays 1950

With its eight lifts, the ski area on Mount Kilben is not only a skiing paradise for families, but also for backcountry skiers.

Plays"—in a new spirit of understanding between nations—exceeded all expectations and enabled the people of Oberammergau not only to reduce the giant mountain of debt that had mounted from the play preparations, but also to invest the surplus in the construction of housing and the improvement of the infrastructure in order to stimulate tourism.

Some of the clichés about Oberammergau that appear persistently in the press today can trace their origin in part to the 1950s. For one thing, within the destruction of postwar Germany, the town had been built up in people's minds into a perfect world, without any notice of Oberammergau's many problems. For another, in the 1950s criticism of the overly commercial marketing of the Passion play was voiced. Too much commotion and too much kitsch threatened to damage the plays' reputation. The people of Oberammergau decisively—and to the present day successfully—steered away from all of this and concerned themselves with the improvement of tourism in order to reduce the financial burden of the Passion plays.

Winter tourism, which had begun in Oberammergau in the 1920s, was stimulated with new chairlifts on Mount Kolben and the Laber aerial tramway. Since 1954 Oberammergau has become a destination for trainloads of winter sports fans from Munich and other large cities, and Oberammergau has once again become the site of skiing championships, as it had been previously in the 1930s.

Constructive Debate in Oberammergau

In the 1960s protests against the Passion play were voiced and went as far as boycotts. The Passion play text, which was accused of having anti-Jewish tendencies, had to be revised. A protracted and at times heated discussion began in the town: Traditionalists were pitted against those willing to reform. The bitter struggle over the text, but also the whole orientation of the Passion play—whether church service or drama—continued into the 1980s. Under play director Christian Stückl and dramatist Otto Huber, the most sweeping reform of the text since 1860 was carried out in the year 2000.

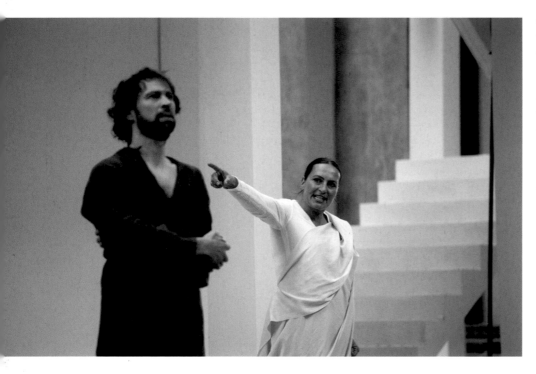

Oberammergau's strong women: The struggle for equal participation in the Passion plays also resulted in the founding of the Oberammergau Frauenliste e.V., from whose ranks women were elected to the local council in 1990 for the first time.

Right: Pulvermoos in winter with a view of Mount Kofel

Not only the content of the Passion play, but also the participation of women was in dispute. After twelve years of discussion, in the end a 1990 decision by the Higher Regional Court stipulated that, in contrast to the earlier rule, married women and women over the age of thirty-five were now also allowed to participate.

Despite all of this, discussions about the Passion plays have not fallen silent: Now as then, there is scarcely another community in which the people engage in debate as much as in Oberammergau. The town can boast of having carried out more citizens' initiatives than anywhere else in Bavaria. This culture of lively debate is sometimes observed with amusement from outsiders, but it demonstrates one thing above all else: The people of Oberammergau have the interests of their town and culture at heart, and they do not leave matters to only a few representatives but feel collectively responsible, an attitude surely worthy of the highest regard.

The Modern Village

Attempts to further improve the infrastructure in Oberammergau have continued in the past four decades. The internationally-known Center for Rheumatism, the beltway to reduce traffic in the center of town, the expansion of the Ammer River against recurrent flooding, the Ammergauer Haus as an information and events center for guests, the construction of the WellenBerg adventure pool, unique to the region: These are just a few of the projects that have already been realized and would be to the credit of any small town.

Since the 1990s a new environmental consciousness has taken root in Oberammergau. As a climatic health resort and vacation destination, the town is particularly concerned with the preservation of its uniquely beautiful landscape by means of environmentally-friendly tourism; this is reflected in the variety of leisure activities and tourism programs available (see p. 99–117).

In addition to maintenance of the infrastructure and tourism, it is culture that occupies the place of primary

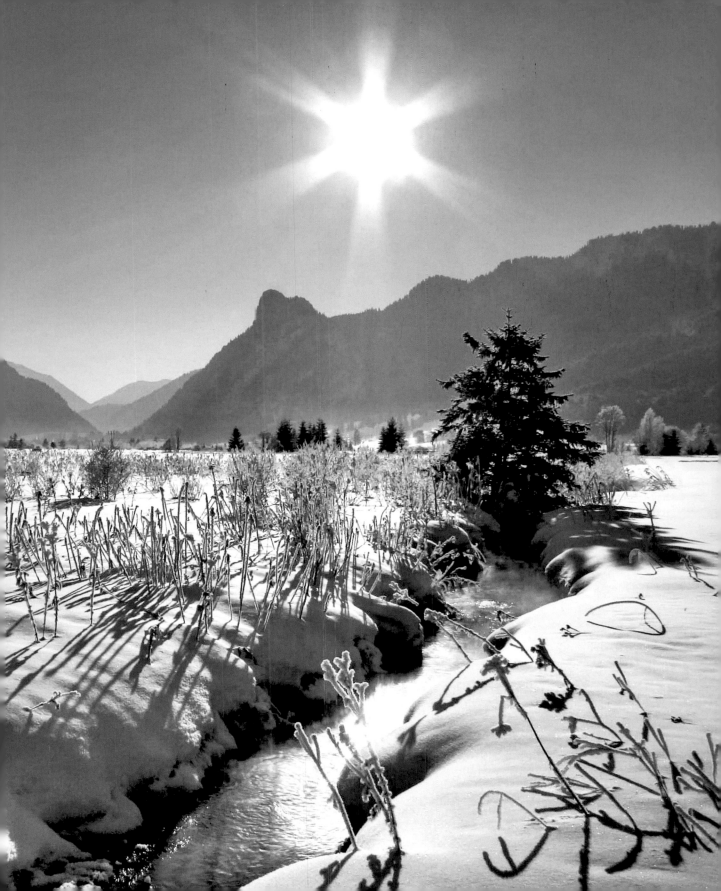

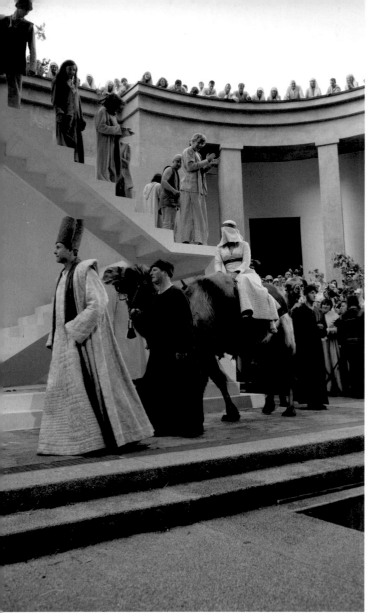

Scene from *Jeremiah* in the Passion theater

Below: Tourist information, restaurants, conference rooms, and many events: The Ammergauer Haus on Eugen-Papst-Straße is the main starting point for guests and locals.

importance in Oberammergau, even when the Passion play is not taking place. The town can look back upon a long tradition of music and theater, which attained a high level early on. As early as 1838, for example, plays by August von Kotzebue—at the time seen more often in the great theaters of large cities—were staged in Oberammergau.

Musical and acting talent have been intensively fostered in the town from the nineteenth century until today; this explains the excellent quality of the singers and instrumentalists of the Passion play as well as of the actors. In the off-season between the Passion plays, the repertoire in Oberammergau includes pieces like *Hunderter im West'ntaschl* and *Brandner Kaspar* as well as German translations of English classics such as *Romeo and Juliet* and *As You Like It*, and even top-quality performances of operas. With a performance of *König David* in July of 2005 and *Jeremias* in 2007 Christian Stückl—Passion play director in the years

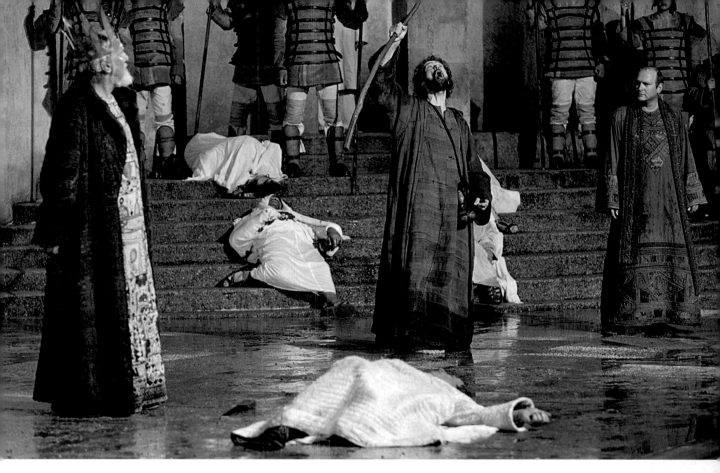

In 2005 the people of Oberammergau presented *König David* (*King David*) in the Passion theater.

1990, 2000, and 2010—has revived the centuries-old Oberammergau tradition of the *Kreuzschule*, or School of the Cross, in which plays from the Old Testament are performed upon the Passion stage in intervening years. Additionally, since 1933, the play *Die Pest* (The plague) has been performed each year preceding the Passion with the same actors; it tells of how the "burning fever" came to Oberammergau, resulting in the plague vow.

The music scene in town is just as distinguished and multi-facetted as its theatrical landscape: The Oberammergau Passion theater is frequently the venue of magnificent classical concerts and brilliant opera performances, admired far beyond the state borders. Traditional folk music, of course, is also promoted in Oberammergau. And even the wild tones of brass band music with techno or punk influences can be heard in the Ammer Valley: In Oberammergau there is something for every musical taste.

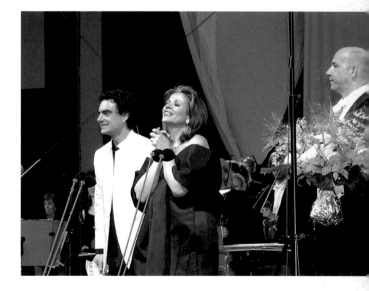

The international opera stars Renée Fleming and Rolando Villazón provided an unforgettable gala evening in the Passion theater in 2008.

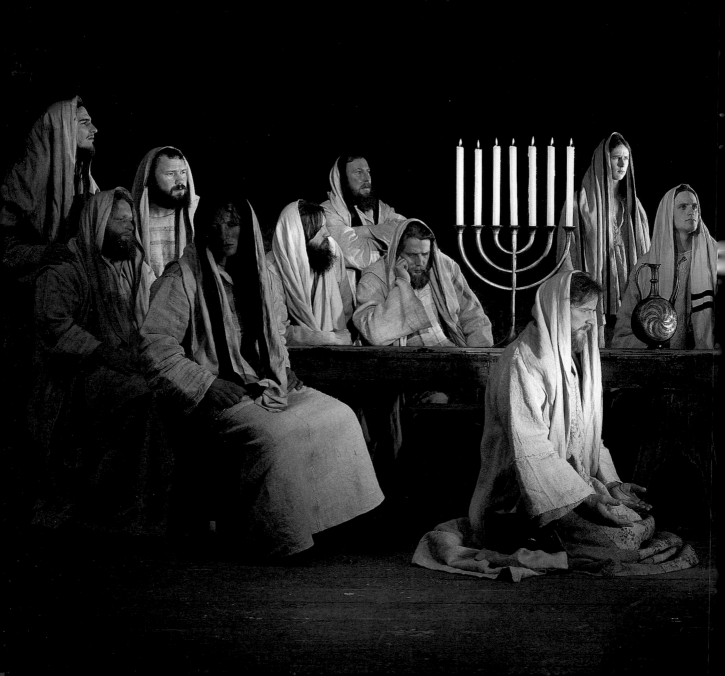

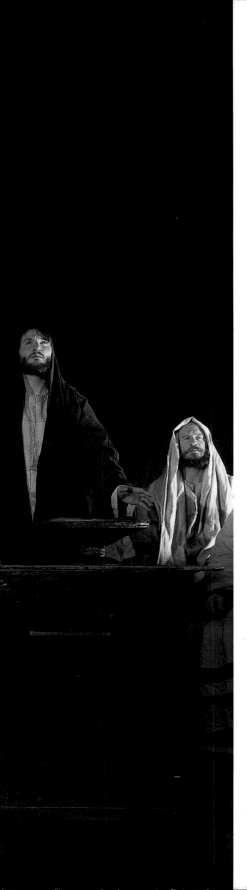

IN THE BEGINNING WAS THE PLAGUE:

The Passion Plays

"The most exciting thing about this work is dealing with the figure of Jesus of Nazareth. I have sought this figure since my youth ... Over and over again the same question: How is it possible to represent Him? A Passion play cannot be merely a historical pageant. But how can matters of faith be brought onto the stage? How to represent the Resurrection, the scene of the Last Supper? Jesus: wholly man and God at once. Actually an impossible task."

Christian Stückl, Passion play director in 1990, 2000, and 2010

Previous double page: The Passover seder

Previous double page: The Passover seder

Below, from left to right:

Backstage: view of the Passion costumes

The "founding document" of the Passion plays, Oberammergau, 1633.
Brochure of the exhibition of 2000 in the foyer of the Passion theater

This wooden dromedary, measuring 6 ft. 7 in. x 4 ft. 9 in., is one of the
oldest surviving Passion play props, from around 1800.

"Jealousy" costume for the Rosner rehearsal, 1977

The Black Death in Bavaria

"The year 1631. Due to the ongoing Swedish war, expensive times, and war unrest, diseases have spread in both Bavaria and Swabia, so that everywhere around here too, a burning fever or headache has come about, from which very many people have died."

From an anonymous Oberammergau town chronicle kept from 1485 to 1733

The Plague Register

Ink damage, fungal infestation, dog-eared corners, tears, and other damage were threatening to destroy Oberammergau's oldest church book, which dates from the seventeenth century. But several years ago the so-called plague register was restored at great expense, and one of the town's most historically valuable documents was saved. Since there is no written record of the plague vow of 1633, the 400-page-long parish register is considered the "founding document" of the Passion play tradition. Among other things, the manuscript list reveals that between the end of September 1632 and October 1633 about ten percent of the village's inhabitants fell victim to the plague. A facsimile version of the parish register is on view at the village church of Saints Peter and Paul in the intervening years between Passion plays. During the period when the play is performed the facsimile is shown in the foyer of the Passion theater in Oberammergau as part of a special exhibition.

A Different Way of Marking Time

For centuries, the village of Oberammergau has thought in the rhythm of the Passion: The birth of a child, the building of a house, a neighbor's funeral—was it before the Passion or afterwards?

During the Passion itself everything revolves only around the play; nothing is built, and fewer people die—this has been demonstrated statistically.

The Passion Play in Brief

The Passion plays take place in a ten-year rhythm, from the middle of May to the beginning of October, and are performed five times per week. In over one hundred performances, each lasting six hours, the events between Palm

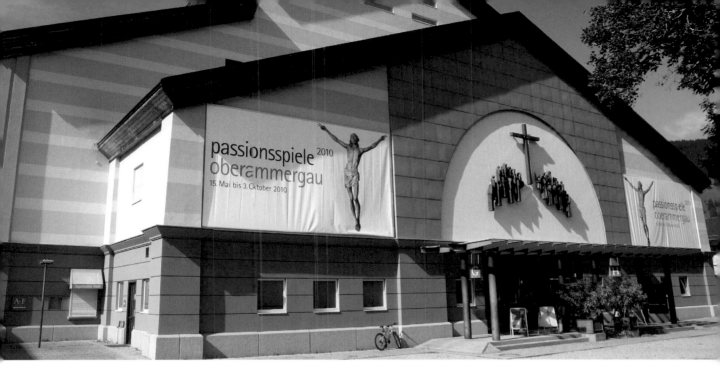

Entrance to the Passion theater

Sunday and Easter are represented. All of the approximately 2,000 participants, from ushers through actors to choir singers, were either born in the village or have lived there for at least twenty years; only in the orchestra is an exception made. For 2010 there are plans for the first time to have the Passion play begin in the afternoon so that after a three-hour break the play is performed into the evening. Over half of the 500,000 visitors expected come from English-speaking countries.

The Passion theater provides seating for 4,750 visitors and is an open-air theater with covered seating. It is even equipped with extendable roofing that makes it possible to perform undiminished in the rain. Everything is perfectly organized: Accommodation, parking, advance sales of tickets, and special arrangements—everything has been thought of; even childcare during the performance is possible.

Love of the Stage

Theater has been performed in Oberammergau for as long as anyone can remember; there are genuine dynasties of amateur actors, and it is not rare for four generations of one family to stand together on the stage. The high quality of acting in Oberammergau is a result not only of the competence of the play's director, but also of the high value placed on theater in Oberammergau from time immemorial: Since the eighteenth century practice plays have been staged in order to prepare the performers for acting in the Passion. These originally took place on the Passion stage itself, which was partitioned for this purpose, but then beginning in the nineteenth century they were performed in the Passion play's own practice theater in the Schnitzlergasse, today's Kleines Theater, or Little Theater.

In Oberammergau not only drama is fostered but a wide variety of music as well, from Bavarian folk music to classical works or even brass-band music with the techno or punk influences of the wild youth. The various Oberammergau choirs as well as music societies ensure the fostering of musical talent, of which there is a great deal: With few exceptions the 110 choir singers as well as the 80-piece Passion orchestra all come from Oberammergau.

The Passion Plays in Oberammergau

Church and theater represent a centuries-old alliance, as can be seen in the Passion play traditions of many European countries since the Middle Ages. In Oberammergau as well, religious plays were staged even before the plague vow of 1633. For several different reasons, not least prohibitions handed down by churchly and secular authorities, the Passion play tradition came to an end almost everywhere in the eighteenth century—except for Oberammergau. Here the Passion play has been celebrated every ten years since 1634, making it the oldest Passion play that has existed continuously until the present day.

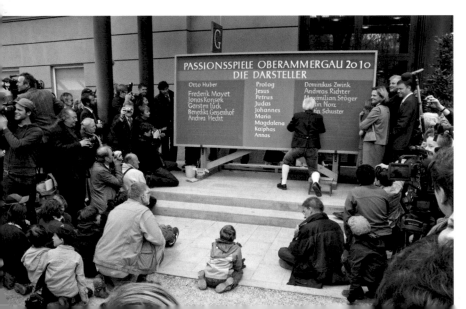

Who will be the next Jesus? Not only all of Oberammergau holds its breath when Willi Häßler, the 'man at the board' since 1960, takes out his chalk to write the two names for each leading role. Here, the announcement of the cast for the Passion year 2010

Facing page: The way to Calvary, Mary accompanies her son

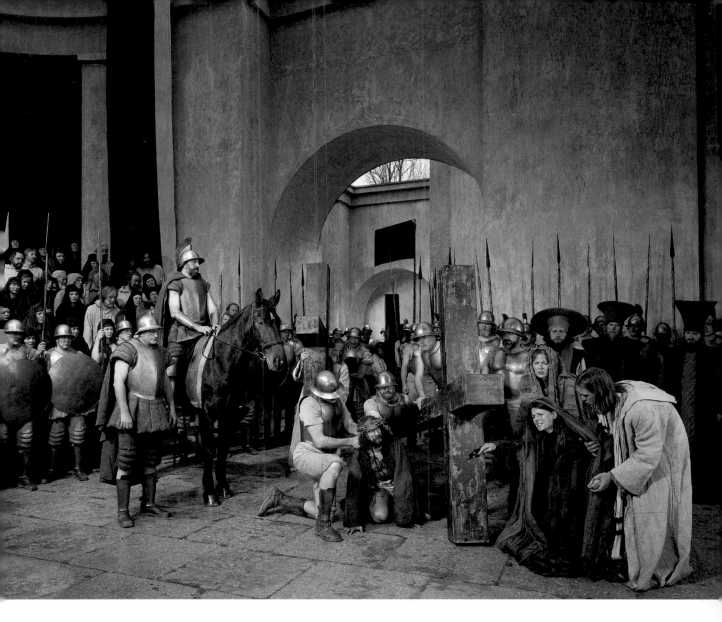

The Prologue

Since 1933 the play *Die Pest* has traditionally been performed every year before the Passion plays in Oberammergau and is both thematically as well as atmospherically the ideal way to prepare for the coming Passion. Its approximately 150 amateur actors also participate in the Passion plays and thus for many in the leading roles *The Plague* offers a good opportunity to prove themselves before a large audience. *The Plague* movingly narrates the story of how the scourge came to Oberammergau, how the months of dying drove the villagers to deep despair, and how they finally took the Passion vow in 1633.

The Plague Vow

Marauding Swedish soldiers, who had advanced into Bavaria in 1632 in the wake of the Thirty Years' War, brought the plague into the land, where it began to spread like wildfire. In the neighboring communities of Eschenlohe and

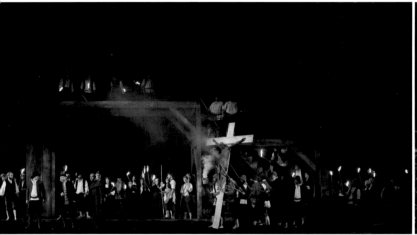

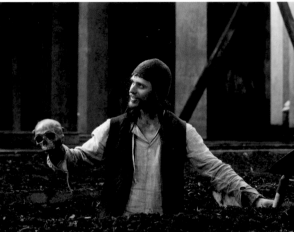

The Plague tells how the Black Death came to Oberammergau: The enraged inhabitants of the village gather in front of the house of day laborer Kaspar Schisler.

The gravedigger is in his element.

"The plague is at the door and no one wants to let it in—but death has already arrived ... he comes first for the rats, then the children, the elderly, and finally no one can hide from him any longer."

The gravedigger Faistenmantel in the play *Die Pest* (*The Plague*) after a text by Martin F. Wall and motifs by Leo Weismantel

Kohlgrub as well "alarming numbers of people died," in the words of an anonymous Oberammergau village chronicler, who simultaneously praised the "diligent" plague watch of his own village, which made sure that the inhabitants were spared. This changed when, in 1632, the day laborer Kaspar Schisler slipped by the guards in order to celebrate the village fair in Oberammergau with his wife and children. Two years earlier he had gone to work for a farmer in Eschenlohe as a summer reaper and now, unwittingly, carried the Black Death into his home village.

Immediately eighty-four adults and an unrecorded number of children died. Subsequently, in 1633, "in the midst of this sorrow in the parish, the Six and the Twelve of the community came together and vowed to hold the Passion tragedy every ten years, and from this time onwards, not one more person died," as can be read in the chronicle, which appeared 100 years later, in 1733.

To be spared from the plague, the people of Oberammergau neither dedicated a church nor offered candles as was done in other parishes. Instead they vowed to perform the Passion every ten years, a project in which everyone in the village could participate. The villagers of Oberammergau built a stage at the cemetery and performed the story of the Passion for the first time as early

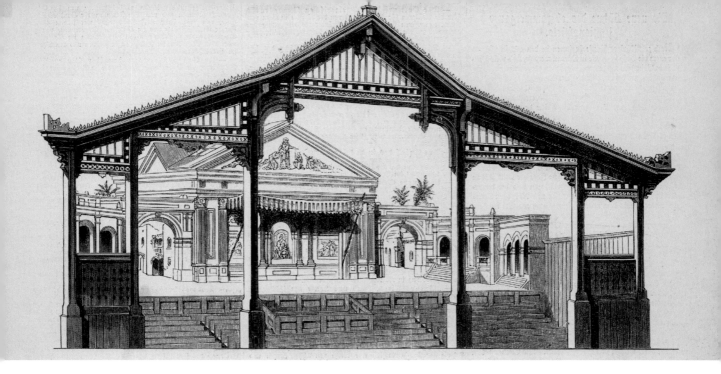

Rebuilding the Passion theater in 1890

as Pentecost of 1634. Since this first performance the Passion plays have been canceled only twice: In 1770 due to Elector Maximilian III's general prohibition against religious plays in Bavaria and in 1940 because of the Second World War. For over 370 years Oberammergau has kept its vow, which is renewed in a solemn ceremony before each Passion year. In 2009 an eleven-year-old altar boy representing the community vowed: "Bearing the vow in mind and in keeping with the promise of our forefathers we shall perform the Passion play in Oberammergau in 2010."

The Passion Theater

The presumably simple stage of wooden boards constructed at the cemetery near the church of Saints Peter and Paul for the first Passion play in 1634 is worlds apart form the present Passion stage with its ingenious architecture and magnificent ambiance. After almost 200 years the wooden stage at the cemetery was moved in 1830 to the site of the present Passion theater. There, in accordance with plans by Carl Lautenschläger, a new

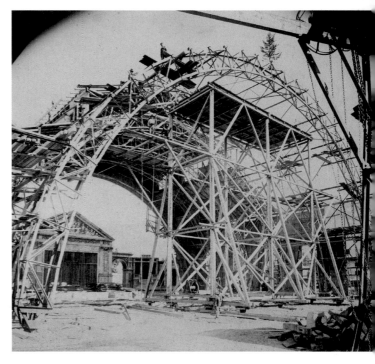

Mounting the iron scaffolding construction of the covered seating area, photograph from 23 September 1899

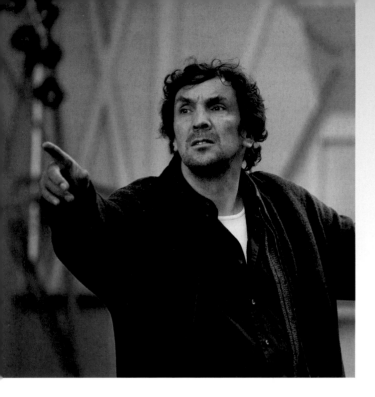

Even as a child Christian Stückl knew what he wanted to be: director of the Passion play in Oberammergau. Like all the directors before him, he first completed his training as a woodcarver at the woodcarving school in Oberammergau before his dream was realized: In 1990, at the age of twenty-nine, he was chosen youngest Passion director in the play's history. In 2010 Stückl is staging the Passion plays for the third time and has promised "a few changes." Already in 2000 under his direction, along with the dramatist Otto Huber, the Passion play experienced its greatest reform since 1860. Since 2002 Christian Stückl has been artistic director of the Munich Volkstheater, but also directs performances on other stages as well, such as at the Munich Kammerspielen, at the Salzburg Festspielen, and on various opera stages.

stage was constructed in 1890, also of wood and based upon the old form. The Passion year 1900 brought a welcome change for the viewers, for the audience space—which until then had not been covered—was now supplied with a roof resting upon a still-extant iron scaffolding of six semi-circular arches. The entire construction, weighing approximately 120 tons, was erected in only three and a half months.

In 1930 the Passion theater was given a completely new face through a reconstruction after plans by Raimund and Georg Johann Lang. While the site, the ground plan, and the sectioning of the wooden stage from 1890 were retained, the theater was given its clear, ascetic, and monumental style in an architecture that has remained essentially unchanged to the present day. The 5,208 seats of the time were reduced to around 4,750 in favor of widening the front stage. Since 2008 the Passion stage has been equipped with a high-tech roof of steel and synthetic materials, which can be extended forward during rain without compromising the atmosphere of an open-air theatre.

Half a Village on Stage

"There will be surprises and disappointments. But I ask you to take them like a sport!" Just before the chosen cast was announced, Christian Stückl, who is directing the Passion in 2010 for the third time, appeared before the assembled crowd on 18 April 2009 and sought to make himself heard: Up to this moment, the list of actors chosen for the 36 leading roles and the approximately 120 speaking parts was known only to him and the local councilor who had approved his casting recommendations. The prime minister of Bavaria, two bishops, numerous guests of honor, the press, and above all the inhabitants of Oberammergau gathered together in front of the Passion theater after an ecumenical church service and looked anxiously at the 'man at the board,' who, with stoic calm, wrote down on the board the names of the two performers chosen for each of the leading roles.

Almost 2,500 Oberammergau villagers—among them over 450 children—had applied with Christian Stückl and will be standing on and behind the stage in 102 performances between May and October. Some of the adult actors

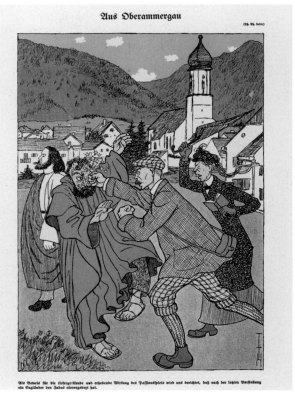

"Adoration of the Apostles in Oberammergau:
Now the holy man can no longer escape us."
Drawing by Rudolf Wilke from *Simplicissimus*, 26 June 1900

"From Oberammergau: As proof of the deeply moving and uplifting
effect of the Passion play, we have received reports that after the
final performance Judas was boxed to the floor by an Englishman."
Drawing by Thomas Theodor Heine from *Simplicissimus*, 6 June 1910

had already participated in the play as small children in the arms of their mothers and still perform today, at a ripe old age.

From the cradle on, the children of Oberammergau grow up with the cycle of Passion preparations: Daily rehearsals must be coordinated for months with school and work schedules, voice training lessons have to be taken, texts studied and costumes tried on—the Passion play demands enormous commitment on the part of its participants. And the many rehearsals also have a wonderful so-

cial aspect: Various generations and inhabitants of the village, who otherwise have little in common, sit together during breaks, speak with one another, and grow together into a dedicated community. This communal spirit is reflected in the play's inimitable crowd scenes, which are full of unaffected, colorful vitality, and are one of the things for which the Oberammergau Passion play is so famous.

But in the past it was not always so simple for the Passion performers to manage the balancing act between real life and stage role: It sometimes happened, for example,

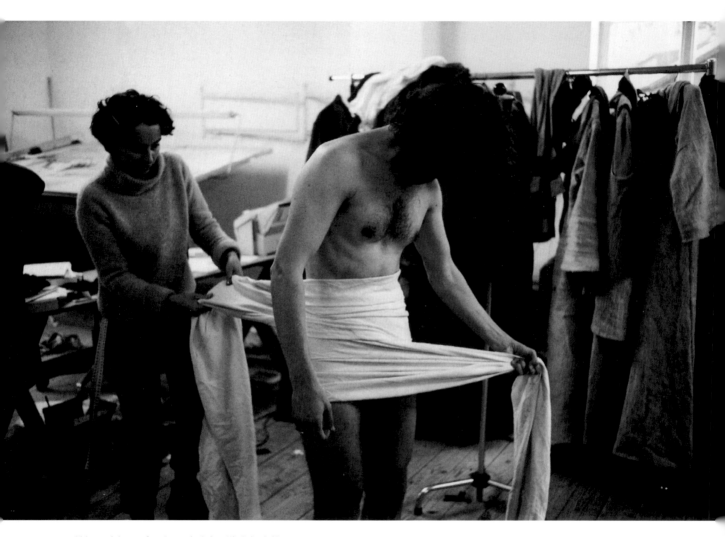

Able assistance for Jesus in tying his loincloth

Christian Stückl rehearses with the youngest actors.

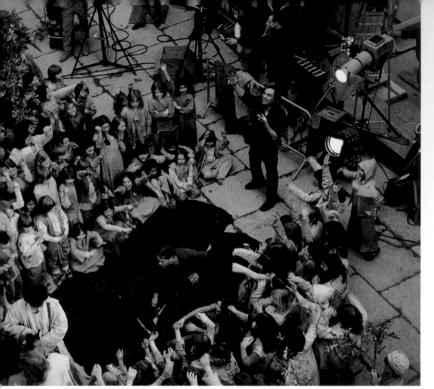

Rehearsing the Entry into Jerusalem

Who Can Perform?

Anyone born in the village of Oberammergau or who has lived there for at least twenty years can participate in the Passion plays. Between 1922 and 1990 women were allowed to participate only if they were unmarried and not older than thirty-five, although the surplus of female actors after the First World War may have contributed to this decision being introduced. Since 1990 both married and unmarried women over thirty-five have been allowed to participate. Nor, since 2000, is religious affiliation any longer a prerequisite for participation in the Passion plays.

that outside the theater Passion visitors looked askance at the actor playing Judas while Jesus and his disciples were the recipients of an almost idolatrous devotion.

The Hair and Beard Decree

About a year before the Passion plays begin a notice hung up at the Passion theater announces the so-called Hair and Beard Decree: From now on, all participants let their hair and beards grow until the end of the plays. Actors playing Roman soldiers, the musicians in the orchestra, and the helpers behind the stage are exempt.

The Passion Text:
From "Tragedy" to Modern Script

The oldest surviving text of the Oberammergau Passion play is a copy from the year 1662 by the Oberammergau schoolmaster Georg Kaiser. Most of the verses are taken from two sources: a late medieval play, the manuscript of which was found in Augsburg's Benedictine Monastery of St. Ulrich and Afra, and the work of the Augsburg Meistersinger Sebastian Wild from 1566.

Oberammergau porters in 1922

The play was then reworked several times until the middle of the eighteenth century by Fathers from the monasteries of Ettal and Rottenbuch and organized into acts and scenes. The piece became the *Passio Nova* in 1750 through a reworking by the Ettal Benedictine Father Ferdinand Rosner, who lent it the formal language of Baroque religious theater. This text was frequently copied in Bavaria, and made Oberammergau into a model for other towns with Passion plays. During

Following in Jesus' footsteps in the Holy Land: The main ensemble of the 2010 Passion plays visits Jerusalem in the late summer of 2009

The oldest surviving version of the Passion text, from 1662

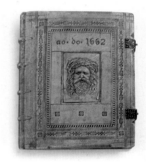

"For the Entry into Jerusalem the community acquired a donkey, which was kept at my house. He soon knew the play so well that he would trot alone to the theater when it was his time and, in his own language, make his presence known at the rear door."

Aus meinem Leben (From my life, 1930) by Anton Lang

The Passion donkey 1950

Right: Joseph Alois Daisenberger, from 1845 to 1883 parish priest in Oberammergau, "exemplified the good priest" (Ludwig Thoma in his *Reminiscences*). The community erected a monument to Daisenberger in the cemetery.

The Passion's team of directors, 2010, from left to right: Michael Bocklet (conductor), Otto Huber (deputy director/dramatic advisor), Christian Stückl (director), Markus Zwink (musical direction), Stefan Hageneier (set design and costumes)

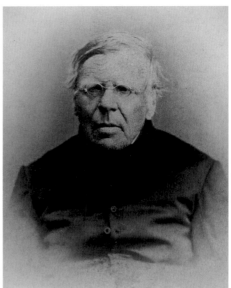

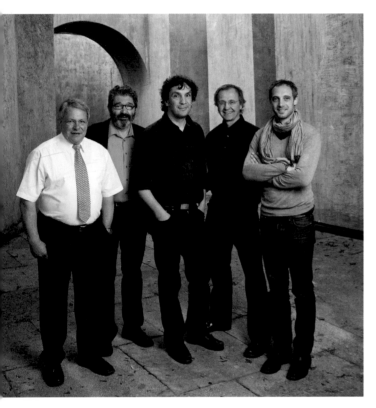

the prohibition against the performance of all religious drama in Bavaria—in 1770 the Oberammergau Passion play did not take place for this reason—Father Magnus Knipfelberger of the Ettal Monastery presented an abridged version and managed to obtain a special drama privilege for Oberammergau.

The first prose version of the text from 1811 originated from the pen of Ettal Father Dr. Othmar Weis and today remains one of the foundations of the script. Between 1850 and 1870 the Oberammergau parish priest and play director Joseph Alois Daisenberger reworked the text several

times; together with the Weis text, this became the second foundation for the present script. An official script with a complete text has existed since 1900.

After the Second World War, discussions about the anti-Semitic tendencies of the Passion play text required several new revisions of the piece. Renowned theologians were asked to help and the community engaged in a decades-long dialogue with representatives of Judaism in Germany, America, and Israel. In the new staging of the Passion play of 2000 under the direction of Christian Stückl and dramatist Otto Huber, passages and representations that could be misunderstood were deleted in order to definitively exclude any possible anti-Semitism. At the same time it was and remains important to Christian Stückl, also in the upcoming Passion, to lend the figures greater individuality and avoid reducing Jesus merely to his suffering, but instead to represent the commitment with which he lived his faith, and which also brought him to the Cross.

The Passion in Notes

Music was first mentioned in the Passion play of 1674: Trumpets were to have accompanied the entrance of the

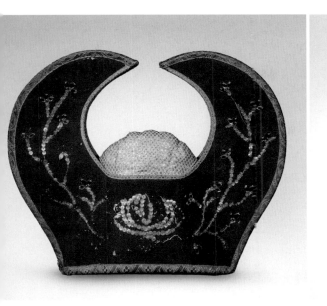 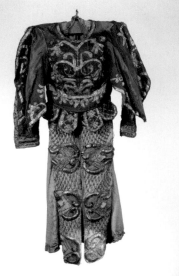 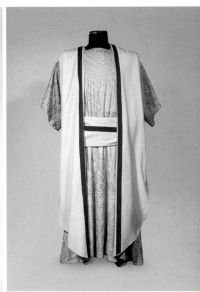

The robe and headcovering of High Priest Caiaphas are among the oldest surviving costumes from the second half of the eighteenth century.

Official attire of Pilate

high priests and Pilate. Great significance was already attached to the music in Father Ferdinand Rosner's reworked Passion play of around eighty years later: He added the "guardian spirits," which became the origins of the great present-day choir and the link between the "living pictures" and the plot. The Oberammergau teacher and church musician Rochus Dedler composed several musical versions for the Passion plays of 1811, 1815, and 1820. One of these versions went up in flames during the great village fire of 1817, in which thirty-four houses and the parish archives were lost; it had only been played once.

In the course of time, Dedler's music was repeatedly changed by the Passion's musical directors and adapted to new requirements. In 1950 the community commissioned Professor Eugen Papst as musical director to revise the Passion music in order to correct and resolve the various changes, many of which were felt to be distortions of Dedler's music. In 2010 Markus Zwink took over the musical direction of the Passion plays for the third time and will also be setting contemporary accents through his own compositions.

Crown of Thorns, Armor, and Brocade Robe: The Costumes and Props of the Passion Plays

The oldest surviving Passion play costumes date from the eighteenth century and are outstanding examples of valuable materials and careful handiwork. The flagellation column, one of the oldest surviving Passion play props, dates from this time as well.

Most of the costumes were replaced in 1880 and 1890 under director Johann Evangelist Lang with the support and advice of the Munich Hoftheater. The designs, many of which were based upon Assyrian and Egyptian models, show the great efforts made at the time to be historically accurate. The new staging in 1930 brought with it great changes in both scenery and costumes; for the first time the figure of Pilate appeared not in armor but in a luxurious official robe, which continued to be used until 1984. For the Passion play of 2000 the stage set and costume designer Stefan Hageneier designed beautiful new costumes and scenery and will also be responsible for the scenery and costumes in 2010.

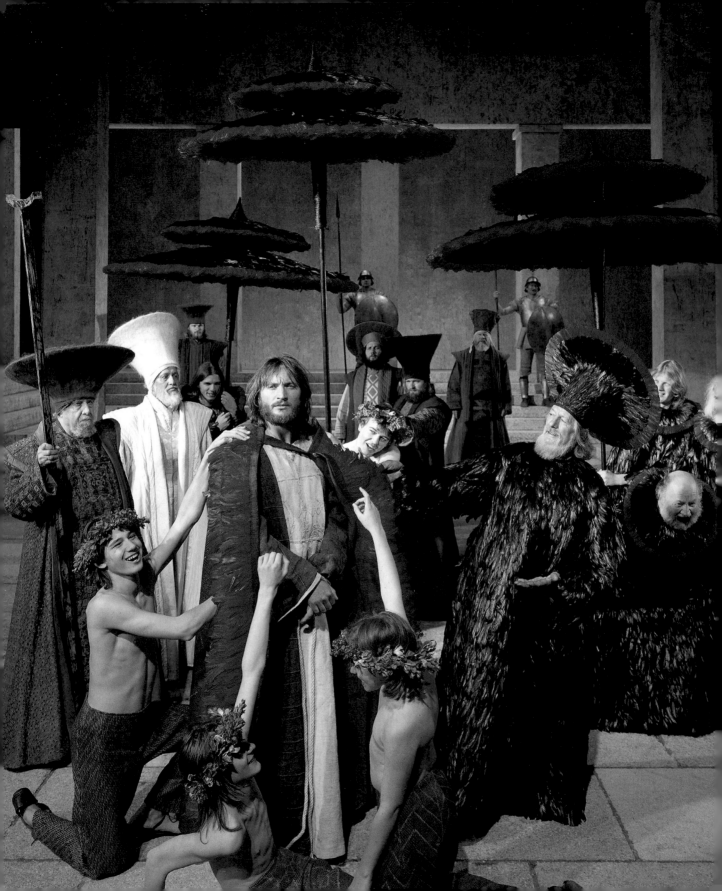

Chronicle of the Passion Plays

1633

Plague vow

1634

The first performance takes place at the cemetery near
the Church of Saints Peter and Paul with 60–70 actors.

1664

Use of the oldest surviving Oberammergau Passion text
of 1662; its verses originate from two Passion plays of the
fifteenth and sixteenth centuries.

1674

Text expanded through the addition of scenes from the
Weilheim play by Johannes Älbl.

1680

Transition to performances in the first year of every
decade, the reason for which is unknown.

1690

The oldest surviving community bill documents expenses
for the Passion play.

1700

Oberammergau resident Bernhart Steinle directs the play.

1710

Prebendary Thomas Ainhaus directs the play and im-
proves the rhyme.

1720

The play is organized into acts and scenes; the space of
the stage is separated from the seating area.

1730

The Rottenbuch Augustinian canon Anselm Manhardt
edits the text and introduces allegorical figures and the
"living pictures."

1740

Verse improved by Rottenbuch Augustinian Clemens
Prasser.

1750

Passio Nova of the Ettaler Benedictine Father Ferdinand
Rosner. Rosner's text becomes a model for other towns
with Passion plays.

1760

Two performances with around 14,000 visitors.

1770

Prohibition of all Passion plays in Bavaria—for the first
time a performance does not take place.

1780

After the text is edited by Father Magnus Knipfelberger—
among other things, the allegorical figures and the scenes
with the devil are deleted—Oberammergau receives a
special privilege for the performance of the Passion.

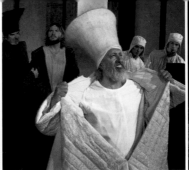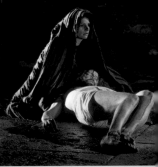

1790

First sale of admission tickets and first mention in the press.

1800

Approval for performance by a privilege of 1791.

1811

After the Oberammergau performance privilege is declared to have ceased in 1801, Passion plays begin to be held again in this year. The new, prose version of the text stems from Ettal Father Othmar Weis with music by the Oberammergau teacher Rochus Dedler.

1815

Special performance after the ending of the Napoleonic wars.

1820

Last performance at the cemetery.

1830

Construction of the stage at the northern edge of the village after plans by Korbinian Unhoch; new theater seats 5,000 audience members.

1840

Newspaper reports by prominent persons in the English press among others leads to an increase in the number of visitors.

1850

Minor editing of text by parish priest Joseph Alois Daisenberger, who also takes over direction of the play. The play's organization is taken over by the Passion Committee.

1860 and 1870

Joseph Alois Daisenberger reworks text, as requested by the government.

1871

Continuation of the play of 1870, which had been interrupted by war.

1880

Johann Evangelist Lang is play director.

1890

Renovation of the stage by Carl Lautenschläger.

1900

Construction of the covered audience hall; first official script with complete text. Anton Lang, who plays Christ, makes a strong impression and gives the play its character.

1910

Around 223,600 viewers in 56 performances.

1922

The plays of 1920, which had not taken place due to conditions after the war, are performed now, directed by Georg Johann Lang, who remains director until 1960.

1930

Rebuilding of stage and expansion of seating area to 5,200 seats.

1934

Jubilee performance with reduced ticket prices and train transportation. Adolf Hitler visits on 13 August.

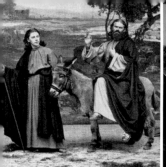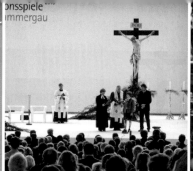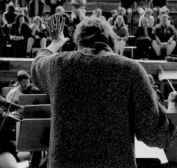

1940

The Passion play is not performed due to war.

1950

Expansion and new orchestration of music by Professor Eugen Papst.

1960

Discussions concerning the representation of Jews in the text and play. Text corrections undertaken by Ettal Abbot Dr. Johannes Höck.

1961

In the round of discussions initiated by the community, Carl Orff recommends reverting back to the Rosner text.

1970

After failed attempts at reforming the text, the community reverts back to a slightly edited version of the Weis/Daisenberger text, which is nonetheless felt to be unsatisfactory and leads to boycotts by the anti-defamation league. Under the direction of Anton Preisinger 102 performances are shown to approximately 530,000 visitors.

1977

An attempt is made with the Rosner text in accordance with Hans Schwaighofer's reform recommendation.

1980

Director Hans Maier, text editing by Ettal Father Gregor Rümmelein; reduction of audience seating to around 4,700.

1984

Jubilee performance with 480,000 visitors in 101 performances; further editing of the text by director Hans Maier and Father Gregor Rümmelein as well as changes in the set design.

1990

Christian Stückl—the youngest director of the Passion to date, at the time 29 years old—and Otto Huber bring about a rejuvenation in the assignment of the leading roles. A court decides that both married and unmarried women over thirty-five be allowed to participate for the first time.

2000

New renovation of the Passion theater. Religious affiliation is revoked as a prerequisite for participation. The most sweeping reform of the text since 1860 is carried out under director Christian Stückl and Otto Huber. About 2,000 new costumes and 28 new stage sets are designed by Oberammergau stage set designer Stefan Hageneier. Markus Zwink, who had been responsible for musical direction in 1990, edits Dedler's music. In the fortieth year of the play's performance 520,000 visitors come to watch.

2010

Director Christian Stückl has performances begin in the afternoon and, after a three-hour break, continue into the evening hours. Otto Huber, Markus Zwink, and Stefan Hageneier are once again, as in 2000, part of the team directing the Passion.

Based upon *Die Erlösung spielen* (Performing the redemption) edited by Helmut W. Klinner and Michael Henker, Oberammergau, 1993 (to 1990); subsequent additions by Annette von Altenbockum

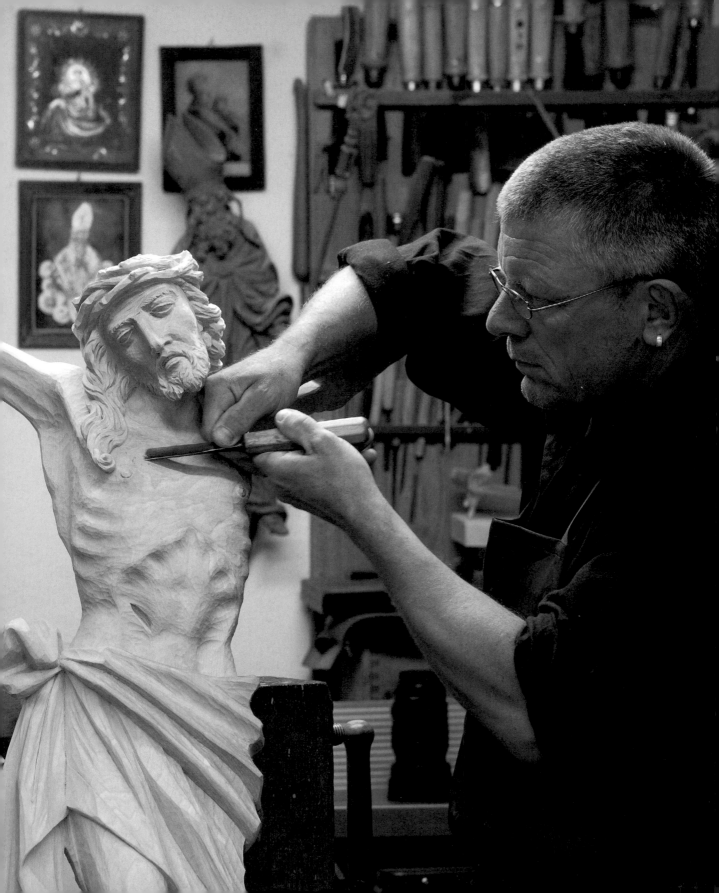

FROM CRUCIFIX CARVER
TO FAÇADE PAINTER

Artistic Tradition in Oberammergau

"**I**n Ammergau the boys enter the world as crucifix carvers."

From *Der Herrgottschnitzer von Ammergau* (The crucifix carver of Ammergau) by Ludwig Ganghofer (1880)

Here unique objects are created, not mass-produced goods: Like the other Oberammergau woodcarvers, Master Woodcarver Florian Haseidl's work is truly made by hand.

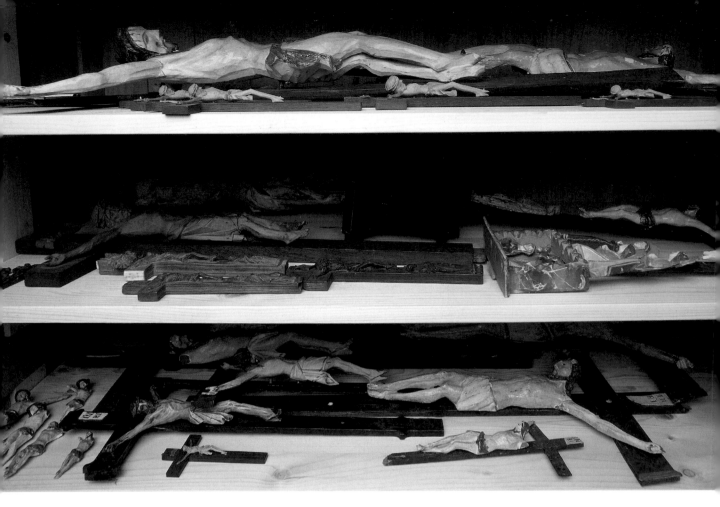

Many a precious object slumbers in the depository of the Oberammergau Museum.

Travel Notes from 1890

"The town has 1,300 inhabitants, most of them are woodcarvers. There is no farming here, and almost no livestock breeding. There's not even any question of a plough. In the large shop of carved works owned by Lang's descendents we see quite a rich supply, a great diversity that is truly astounding. A larger shop of this kind cannot be found in any city."

From the travel journal *Einmal Oberammergau und zurück* (Once to Oberammergau and back) by the farmer Matthäus Storath, kept in the Passion year 1890

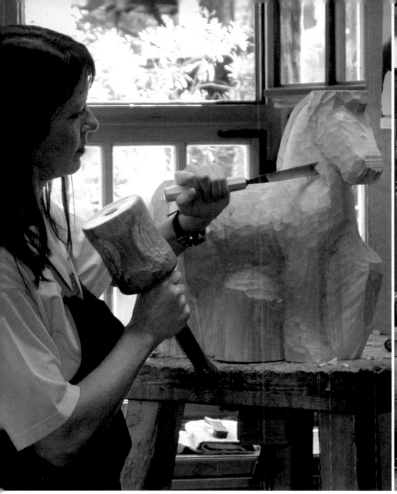

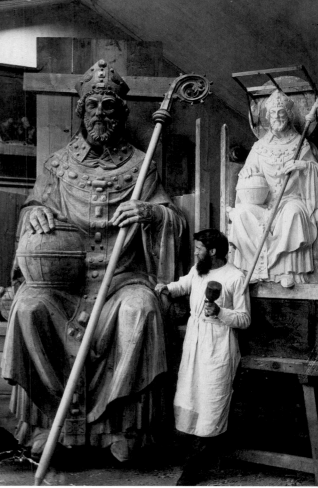

Master Woodcarver Helga Stuckenberger played Mary Magdalen in 1984, 1990, and 2000.

Joseph Albrecht at work on a monumental sculpture of Saint Rupert for the Church of Saint Rupert in Munich, around 1903

Only Authentic when Stamped

Originally founded in 1836 as a mutual aid society of woodcarvers for mutual support in case of illness or emergency, today the St.-Lukas-Verein (Society of Saint Luke) represents the concerns of its members, maintains the cohesion of Oberammergau's wood sculptors, and presents their work in annual exhibitions. In order to help the non-specialist distinguish Oberammergau's unique hand-carved works from copies, the former carry the society's official stamp.

Only regional handicraft firms that guarantee their work is handmade in the Ammergau Alps and whose artists have been practicing the trade for at least three continuous years are allowed to tout the quality seal "Ammergauer Alpen KunstHandwerk." At least two of the following criteria must also be fulfilled: production and form from the firm's own designs, no industrially-produced mass products, raw materials originating from the Ammergau Alps, and/or a connection to the customs and culture of the region.

Handicrafts

The handicraft tradition in Oberammergau dates back to the Middle Ages. In 1508 the Florentine Francesco Vettori wrote in his travel account *Viaggio in Alemagna* (Travels in Germany) about the Oberammergau woodcarvers: "... where the majority of the inhabitants, in order to live, made the finest woodcarvings and crucifixes or even other kinds of images carved into nutshells and the like, which they then carried away to sell."

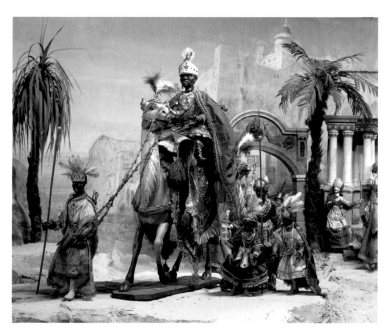

For over a century, generations of Oberammergau woodcarvers have worked on the Oberammergau church crèche, which was created for the parish church of Saints Peter and Paul, completed in 1742. The crèche was not a commissioned work, but produced on the initiative of the carvers. The oldest of the approximately 200 figures dates from the eighteenth century. This illustration shows a detail of the three kings' procession. The historical crèche can be seen in the Oberammergau Museum.

Facing page: Balcony figures in the Oberammergau Museum

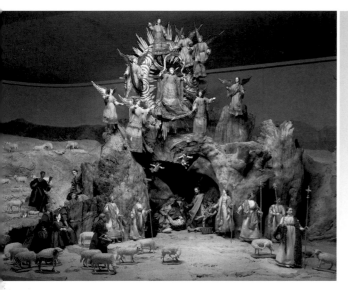

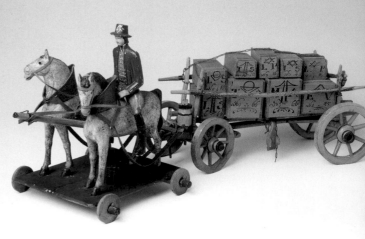

A wooden toy in the form of a transport wagon

Top: The crèche collection of the Oberammergau Museum displays a rich selection drawn from the great variety of Oberammergau crèches.

Bottom: "Here I lie as a child, until as a judge I punish sins." The verre églomisé image *Jesuskind mit Leidenswerkzeugen* (The Child Jesus with the instruments of the Passion) was produced around 1850 and can be seen in the exhibition *Welten hinter Glas* (*Worlds Behind Glass*) in the Pilate House.

The "carrying away to sell" was done at the time by *Kraxnträger*, or pack-bearers, who traveled through the country as peddlers. But already by the beginning of the eighteenth century merchants from Oberammergau were founding branches of the business throughout Europe, where they sold the woodcarvings made at home. In the town itself, from 1775 onwards, one woodcarving merchant, the carver and glass and façade painter Georg Lang, encouraged by the ever increasing demand for works carved in wood, quickly built up his small artisanal business into a trading concern. It soon became the most important employer in town.

In addition to woodcarving other handicrafts developed in Oberammergau: The oldest list dates from the year 1786 and appeared in the official publication *Chur-Pfalz-Baierischen Regierungs- und Intelligenzblatt*: over 30 woodcarvers, who produced crucifixes and "thus were mostly called crucifix carvers," 18 joiners, 10 gilders, and 9 glass painters were registered in the town at the time. Just under fifty years later 68 of the 218 households—

The finely turned and carved ring boxes and the thin needle case, the tops of which can be unscrewed, represent miniature copies of the monuments of famous persons.

Recreation of an Ammergau pack carrier, around 1890

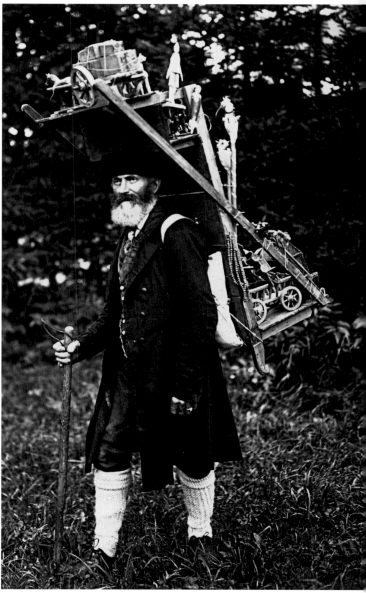

around thirty percent—were already directly or indirectly active in the arts. The range of Oberammergau artisans extended from woodcarvers and wood painters through joiners, turners, wax embossers, gilders, crèche builders, and verre églomisé painters, to mirror grinders, makers of glass Crosses, and potters. Over time the structure of the art trade has changed repeatedly in Oberammergau; some trades became less important while others flourished.

Oberammergau's artists have left their signature throughout the world, and continue to do so today. Whether carved altars in America, monuments in China, sculptures for porcelain manufactures, or contemporary sculpture, the wide-ranging creativity of Oberammergau's artists also continues in the younger generation. Around sixty handicraft businesses still exist in Oberammergau. Their traditional working techniques—some of which have become quite rare—can be experienced live in the "living workshop" of the Pilate House.

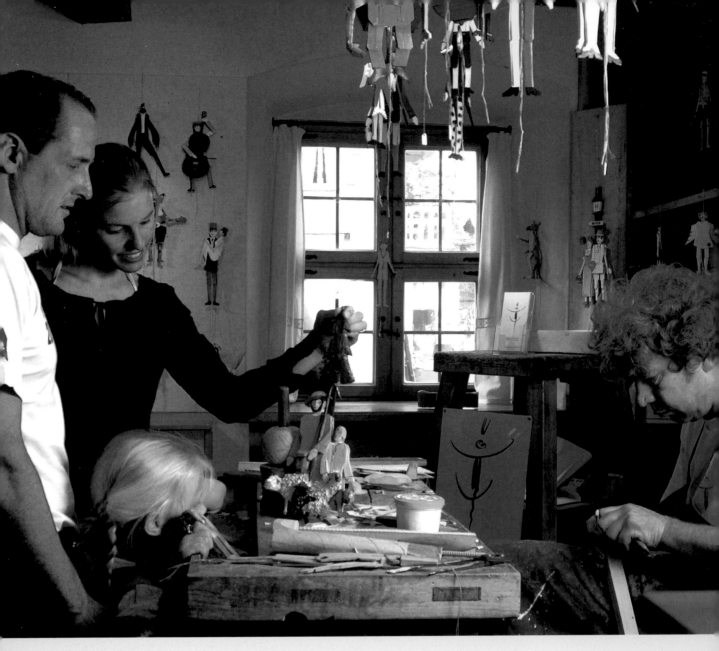

The "Living Workshop" in the Pilate House

From the middle of May to the middle of September and during the time leading up to Christmas, bustling activity takes over the ground floor of the Pilate House in the afternoon: Woodcarvers, weavers, verre églomisé painters, basket weavers, builders of stables for nativity scenes, sculptors, potters, and painters—to name just a few of the handicrafts in town—give visitors the opportunity to watch them at work and ask questions. The idea of the "living workshop" has been realized in Oberammergau with success for more than thirty years and is especially popular among families with children; admission is free.

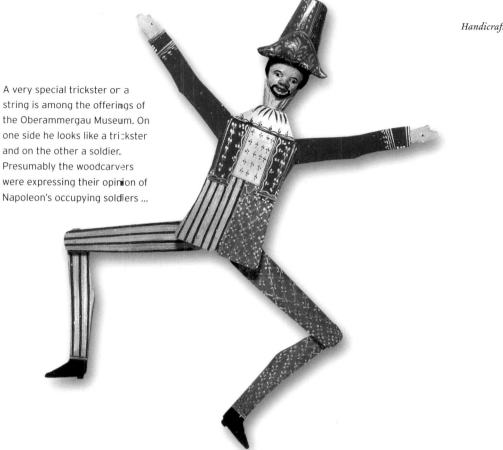

A very special trickster on a string is among the offerings of the Oberammergau Museum. On one side he looks like a trickster and on the other a soldier. Presumably the woodcarvers were expressing their opinion of Napoleon's occupying soldiers ...

From Crucifix to Trickster on a String

Oberammergau's great variety of woodcarvings are impressive in their dimensions—from the nutshells mentioned above to sculptures many feet high and church altars—as well as in their cutting technique and materials, and their diversity of motifs: In addition to religious works such as crucifixes, crèche figures, or miraculous images, profane woodcarvings are also produced in series and exported throughout the world: *Hampelmänner*, or tricksters on a string, small toy figures such as farmers and soldiers, animals, wagons, and jointed dolls, but also lavish table games for adults, precious needle cases, and small chests. The Oberammergau Museum displays an extensive selection of these works, not only making the craft's history and the woodcarvers' great skill accessible to the visitor, but doing so by means of an exciting and contemporary museum experience (see p. 36).

Highlights from the Oberammergau Museum

After being greeted by a large wood sculpture of King Maximilian II at the museum's entrance, the visitor first moves toward the "frozen theater," the exhibition of nativity scenes. It displays a magnificent selection of very diverse crèches: from the great paper crèche by façade painter Franz Seraph Zwinck to the smallest clothed crèche with figures only seven centimeters high, to the famous Oberammergau church crèche, which deeply impressed King Ludwig II, and which he expressly traveled to Oberammergau in 1872 to see. An interesting aspect of the various crèche figures is their clothing, in which the costume history of the Passion is reflected.

On the second floor the visitor is led through several historically furnished rooms, most of which have been authentically preserved. A wide variety of toys, including a moveable model of the French conquest of the fortress of Scharnitz in 1805 and sample cases with miniature toys

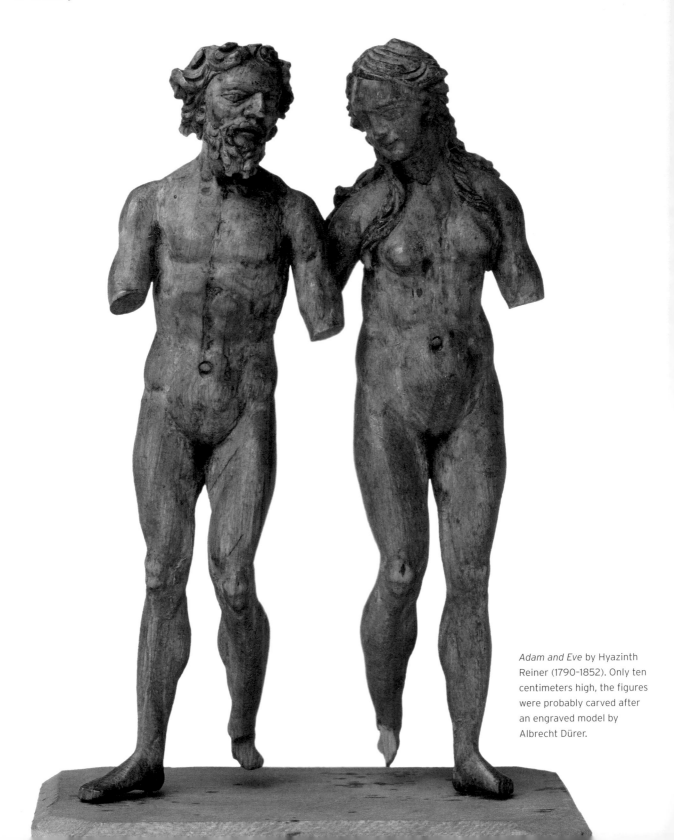

Adam and Eve by Hyazinth Reiner (1790-1852). Only ten centimeters high, the figures were probably carved after an engraved model by Albrecht Dürer.

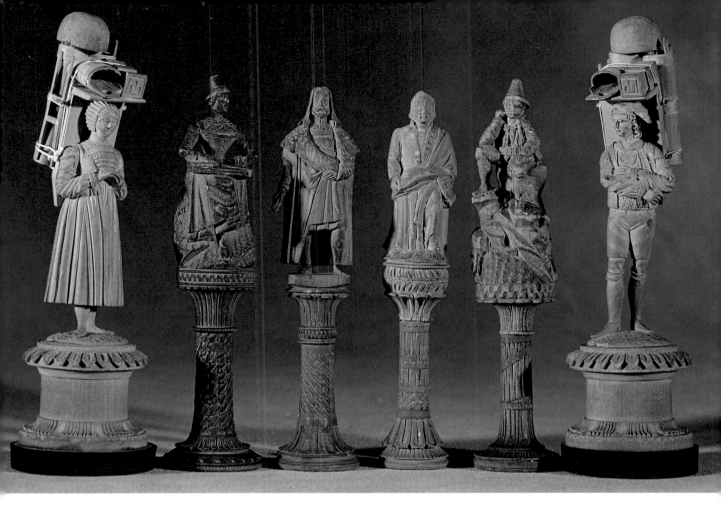

On the left and right, two ring boxes with a Swiss Alpine dairyman and dairywoman with trousseau. In the center, four needle cases; the examples on the outsides show a Tyrolean woman with a zither and a Tyrolean hunter. Between them can be seen miniature copies of the Albrecht Dürer Monument in Nuremberg and the Schiller Monument in Stuttgart.

offer a fascinating glimpse into Oberammergau's successful and widely exported toy production up to the end of the nineteenth century. Themes such as the Last Supper or the so-called *Kofljagd* are wonderful examples of fine religious and profane carving, which can also be admired in Oberammergau.

The visitor is led through two more rooms that bring the past alive: One, the bright and solidly bourgeois room of an Oberammergau woodcarving merchant (the *Verlegerstube* or office room), and the other, dark, narrow, and simply furnished (the carvers' room), originally in the house of the woodcarver Thomas Rendl (1838–1916).

The impressive collection of crucifixes and works by twentieth-century Oberammergau woodcarvers and sculptors offers a glimpse into the great range of the art of woodcarving: from religious to profane, from traditional to modern works of art. The attic is devoted to temporary special exhibitions.

In addition to the information stations, which entertain and inform the visitor throughout the exhibition, the media kiosk in the gallery offers an additional service: Detailed information and photographs of the life and work of Oberammergau's woodcarvers, artisans, and former students of the woodcarving scool from a period of over 250 years can be accessed on the computer terminal.

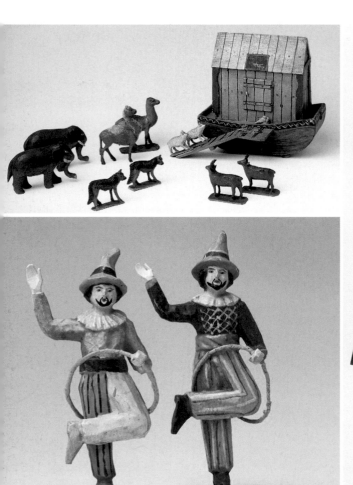

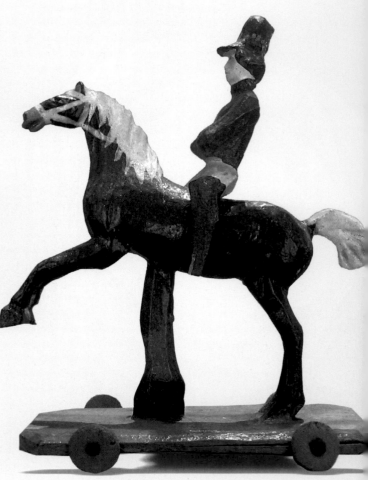

Until the end of the nineteenth century, the people of Ober-
ammergau exported their wooden toys throughout the
world. Industrialization then produced competition that, for
a long time, supplanted wooden toys: industrially produced
toys of tin conquered the nursery.

Upper left: Noah's ark

Lower left: Two figures artfully worked down to the
smallest detail

Right: Horseman from the Oktoberfest procession

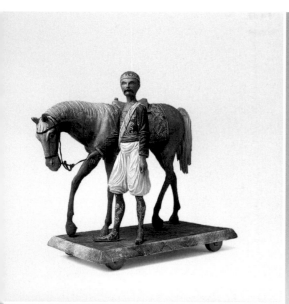

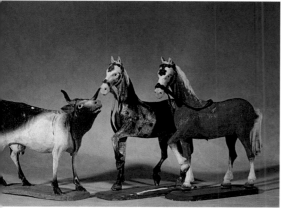

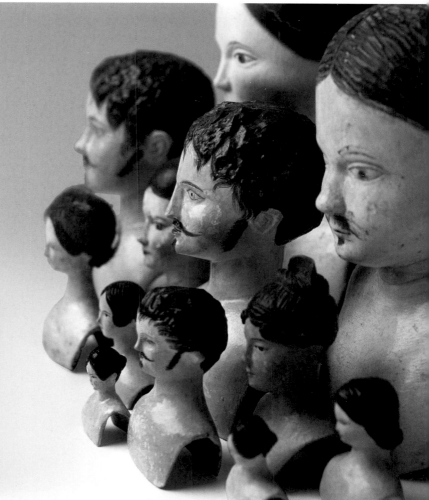

Upper left: This oriental figure leading a stallion was carved by Hyazinth Reiner and was a toy for the prince.

Lower left: Although at the beginning of the nineteenth century, animal carving was the domain of women, the carving of horses remained the preserve of men.

Right: Like other toys, dolls' heads were produced in series.

The woodcarving school was opened in 1909 on Ludwig Lang Strasse. The old building on Ettaler Strasse had become too small for the hundred students at the time, and so Franz Zell was commissioned with the new building.

Facing page: Woodcarving school director Ludwig Lang (1844–1939)

The Woodcarving School: Springboard to the Academy

In the garden of the Oberammergauer Staatlichen Berufsfachschule für Holzbildhauer—the official name of the woodcarving school—a dog waits at the crosswalk for the light to change; a few steps away sits a slumping beggar asking for alms, both motionless but full of life. They are wooden sculptures by the students, which greet visitors to the school's annual exhibition. During this time, the rooms of the venerable school are transformed into a gallery where the three classes with their roughly fifty students each present their works. In the exhibition the student's wide-ranging artistic as well as practical training can be clearly seen in the various fields of study: Drafting, forming, work in sculpture, drawing, joining, turning, painting, gilding, various casting

Worlds Behind Glass

While the "living workshop" on the ground floor of the Pilate House is the scene of bustling activity, the collection of verre églomisé works, displayed in four rooms on the second floor, radiates the delightful charm of a much more leisurely pace. The collection is among the largest in Europe and also exhibits works of verre églomisé that inspired the paintings of artists such as Wassily Kandinsky and Gabriele Münter.

The verre églomisé images are from the collection of Murnau master brewer Johann Krötz, who, like Oberammergau's woodcarving merchant Guido Lang, was a member of Munich's Society for Folk Art and Folklore. Until the end of the nineteenth century Krötz collected over a thousand works of verre églomisé from Oberammergau and the region around the Staffelsee—Murnau, Seehausen, Uffing—thus assembling a very early, complete group of works from this important region of production. In 1955 the community of Oberammergau acquired a large part of the Krötz Collection, and in 1987 a donation made it possible for the museum to expand its holdings to include numerous works from the Bavarian Forest and the Bohemian Forest as well as other regions.

techniques and work in stone are on the lesson plan. But it is worth a visit not only during the annual exhibition. Guided tours are offered, which give the visitor an interesting glimpse into the history and stories of the woodcarving school.

From early on Oberammergau knew how to foster its young artistic talent: The first drawing courses here date back to 1802–03; beginning in 1836 they were led by academically-trained instructors at a drawing school. The woodcarver and school director Tobias Flunger also introduced instruction in modeling forms in addition to drawing them.

His successor Ludwig Lang introduced instruction in woodcarving in 1877, thus transforming the drawing school into a school for woodcarving. A new building was constructed after plans by the architect Franz Zell, who had also designed the Oberammergau Museum. The woodcarving school has been housed in this building since 1909, and an extension is being planned.

Admission to the school is very coveted among aspiring artists. After their journeyman's exam in woodcarving, students have laid the foundation for professions such as set designer, restorer, cabinetmaker, and graphic designer, or they can work towards their master craftsman's diploma, or study at an art academy.

Verre Églomisé

The technique of verre églomisé, or reverse painting on glass, fascinated people already in antiquity. In the sixteenth century this art—originally reserved for emperors, the nobility, and the clergy—spread from Italy to central Europe. Beginning in the mid-eighteenth century verre églomisé was discovered by folk art and became widely popular before being supplanted by cheaper colored lithographs in the course of the nineteenth century.

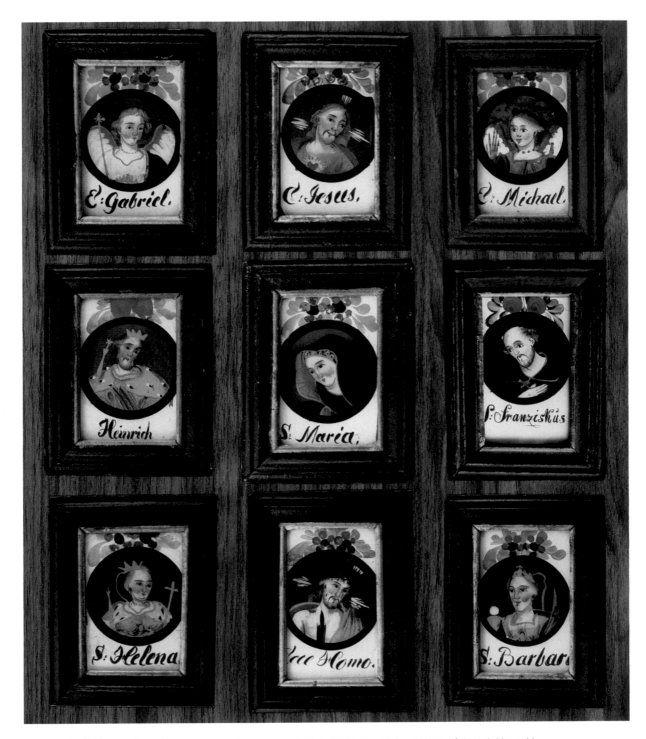

Verre églomisé images from Oberammergau (from around 1800 to 1850), from the workshop of Joseph Mangold

Inspiration for the Blaue Reiter

Wassily Kandinsky and Gabriele Münter became acquainted with the Krötz Collection in Murnau in the early twentieth century and, together with their artist colleagues from the Blaue Reiter, were delighted with the glass paintings' coloristic and formal language. They began collecting themselves, drew inspiration from the images, and adopted the technique for their own compositions. The high value these artists placed on verre églomisé painting is indicated by the fact that Franz Marc and Wassily Kandinsky included nine images from the Krötz Collection in their almanac *Der Blaue Reiter*, the most important artistic manifesto of the twentieth century.

Lüftlmalerei

Oberammergau is one of the birthplaces of Bavarian *Lüftlmalerei*, or façade painting, which spread from Italy to the foothills of the Alps in the eighteenth century. Several centers of this art grew up along the trade route between these places; one of them was Oberammergau.

The charm of *Lüftl* painting can be seen not only in the large themes but also in the small details, whose discovery elicits special delight.

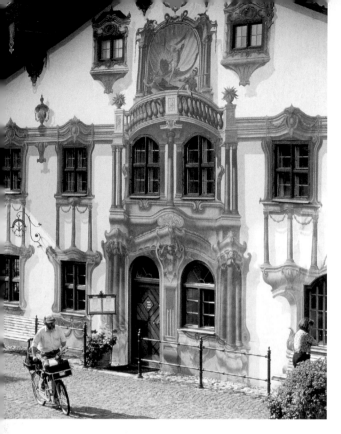

The east façade of the Pilate House on Ludwig Thoma Strasse (see p. 30)

Facing page: The State Forestry Office was painted largely by Franz Seraph Zwinck around 1785. The *Lüftl* painting of the front façade is more recent, dating only from the last century.

Affluent merchants, farmers, and artisans had their houses decorated with this special painting technique, which remains characteristic of Oberammergau even today. In the technique of *Lüftlmalerei*, the paint is applied directly into the wet plaster and binds to a weather resistant layer when it dries. The motifs are drawn primarily from religious themes; many make reference to the Passion plays. But also frescos of fairy tale motifs and stories about the house's inhabitants or from the town's chronicle—not seldom with humorous allusions for insiders—decorate the walls of Oberammergau's houses. Many of the houses exhibit small plaques on which their history can be read.

"A Painter Not to Be Scoffed At ..."

This description of Oberammergau's most famous *Lüftl* painter, Franz Seraph Zwinck, can be read in Oberammergau's death register. Although he died in 1792 after a long illness, at the age of only forty-four, he left behind an extensive and impressive oeuvre: ranging from the ceiling painting and frescos with which he decorated the parish church of Saints Peter and Paul and the pilgrimage chapel in Unterammergau as well as churches in the immediate vicinity, through oil paintings and portraits, to the façade paintings for which he, and Oberammergau, have become world famous. His most famous work can be admired at the Pilate House, but also the present-day Forestry Office—at the time the home of prebendary Joseph Daser—the Kölbl House, the Hohenleitner House, the so-called Mußldona House, and the Gerold House are examples of his outstanding art.

During his life Franz Seraph Zwinck was referred to simply as a painter in all of the community and church records; he would only later be called a façade painter. Whether the term *Lüftlmalerei* originated with him—for a time he lived in a house called Beim Lüftl (Near the breezes)—is not historically documented. The name for this technique may also have come from the artists' rapid work at breezy heights or Alois Frietinger's short story *Der Lüftlmaler von Oberammergau* (The *Lüftl* painter of Oberammergau) of 1910.

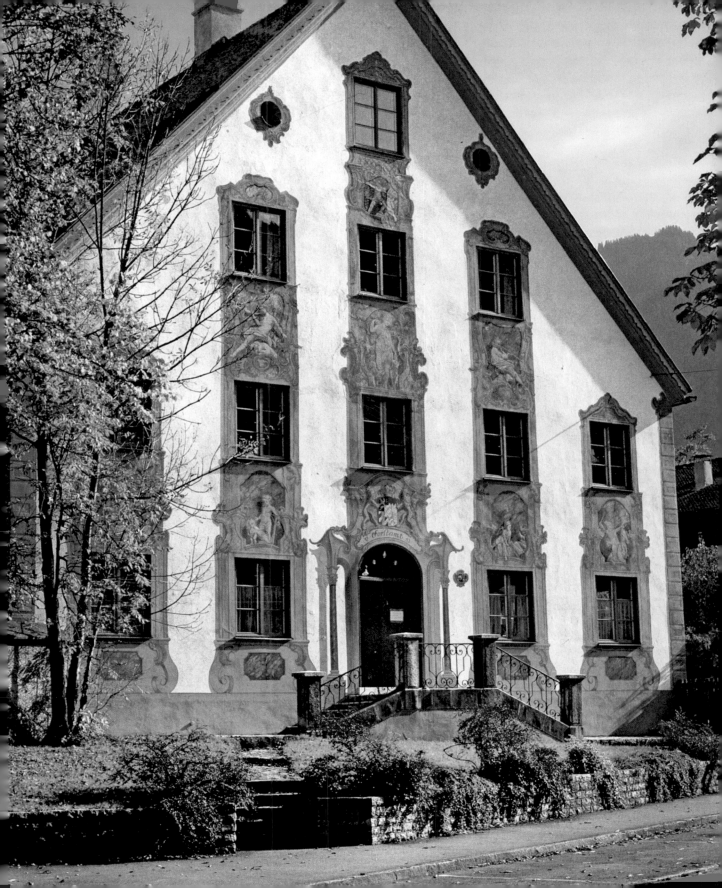

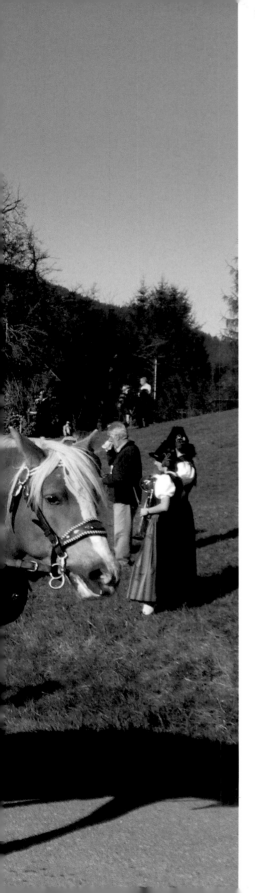

Customs in and around Oberammergau

"**T**rue to the good old customs"

Campaign slogan of the D'Ammertaler, Oberammergau's society for traditional costumes

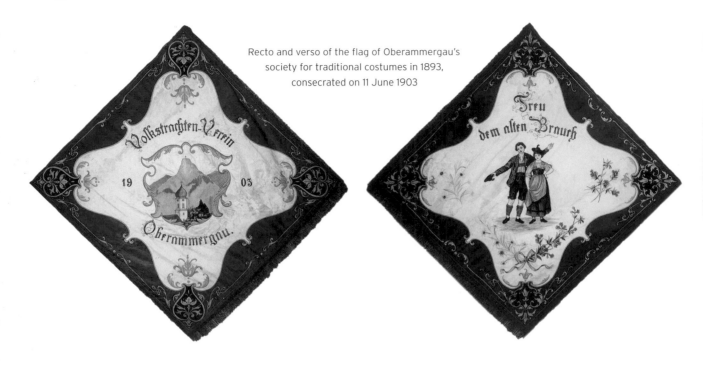

Recto and verso of the flag of Oberammergau's society for traditional costumes in 1893, consecrated on 11 June 1903

Citizens of Oberammergau in their traditional regional costumes (with *Kraxnträger*, or pack carrier) for the procession celebrating the prince regent in Munich on 12 April 1891

Facing page:

Upper left: Boy with a baritone

Upper right: Traditional holiday costumes with their otter bonnets for women and little crowns for girls.

Below: *Schuhplattler* dancers and their *Dirndln*, or lasses

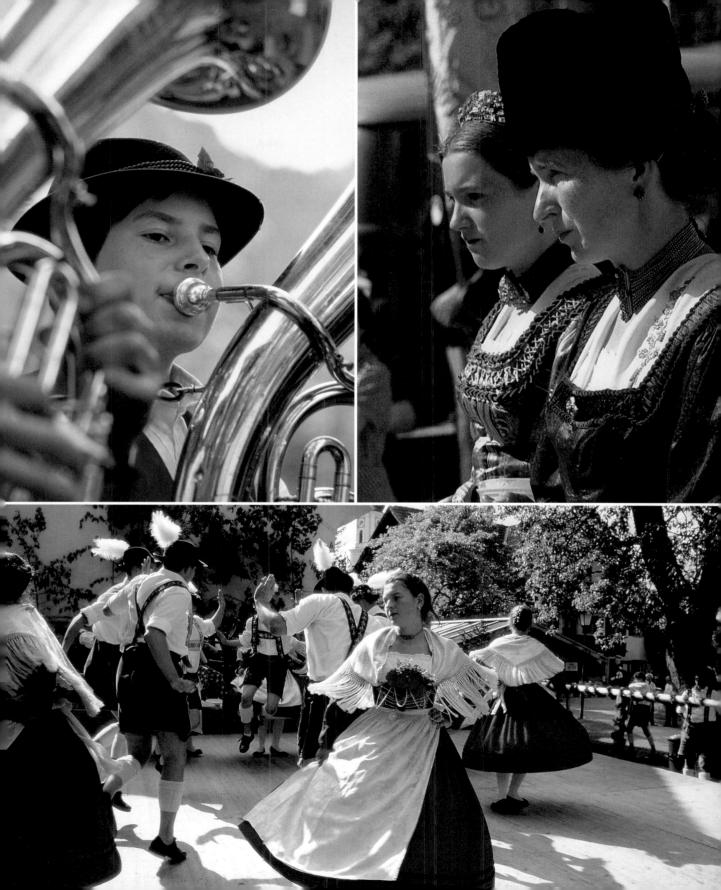

Traditional Annual Festivals in Oberammergau

Oberammergau is world famous for the Passion plays, its works of artisanship, and its theater and music traditions. But there are also many traditional festivals and customs to be discovered in Oberammergau and its surroundings. Some have existed for centuries and continue to be celebrated today.

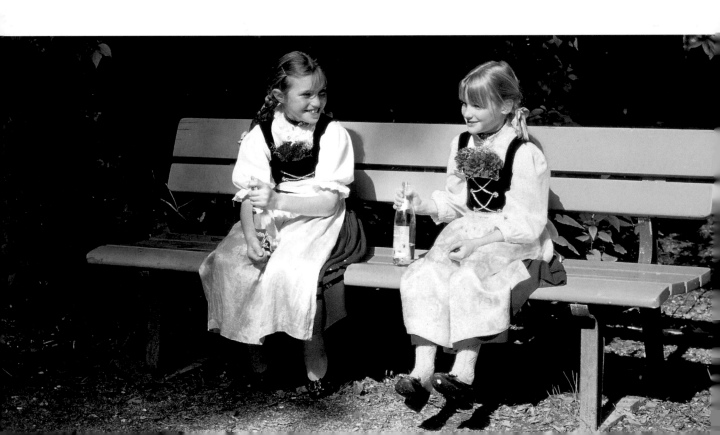

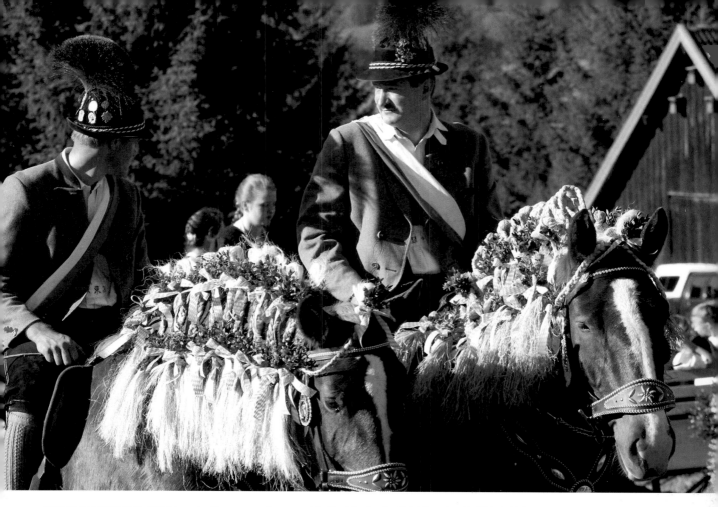

With its approximately 140 decorated horses, carriages, and festival floats, the Saint Leonhard's Ride in Unterammergau is a highlight of the traditional festivals in the Ammer Valley. Each year it draws thousands of visitors.

The King Ludwig Race in Oberammergau is a part of the Worldloppet Tour, a series of skiing marathons through the entire world.

King Ludwig Race

It is indisputably Germany's most popular and largest amateur cross-country skiing race: Every year since 1968—when the weather has permitted—on the first weekend of February Oberammergau has hosted the König-Ludwig-Lauf, in which roughly 4,000 participants take to the ski course. The athletes, who come from over thirty countries, ski in the footsteps of King Ludwig from the start in Ettal, through the Granwang Valley to Oberammergau, where the finish line at the Sport Center is the site of the exciting climax every year. The skiers can choose between the shorter (23 kilometers, or about 14 miles) and the traditional, longer course (50 kilometers, or about 31 miles), which passes directly by Linderhof Palace and can do the course either in classical or free technique. Children and teenagers from six to fourteen can participate in the five-kilometer-long "Mini Kini" (about 3 miles) and are cheered on by the large audience's applause and encouragement just as much as the older participants.

Fishing for Pretzels

When the carnival parade winds through town on Shrove Tuesday Oberammergau comes alive. The children gather in particular around the floats from which pretzels and sausages are dangled with fishing line—now's the time for agility and speed! The town's older inhabitants remember this tradition from their fathers' childhoods. Having been forgotten in the meantime, it was revived in the 1960s by the society for tradi-

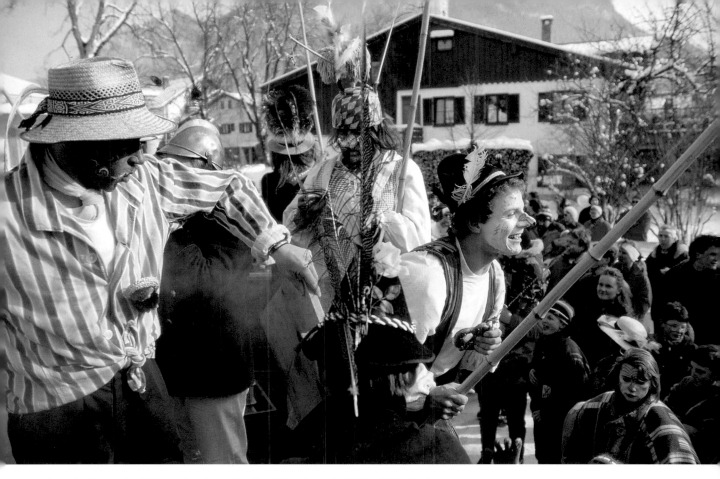

Snapping it closed quickly and heading off to the children's carnival in the Little Theater

tional costumes and today is once again the source of great fun.

In a Passion year Oberammergau does not celebrate carnival, but at least a few children do not have to go without their free pretzels, for on the first day of school, teachers distribute so-called Marxer pretzels among the first graders. In 1927 an endowment by the retired senior teacher Leo Marxer laid the foundation stone for this tradition, which the community still carries on.

Easter Arts Fair

Every year on the Saturday and Sunday—Palm Sunday—before Easter, around forty artisans from Oberammergau and the surrounding area are invited to exhibit and offer their works for sale in the Ammergauer Haus. In addition to works by woodcarvers, porcelain painters, and potters, there are also objects produced in the Abbey of Ettal and artistic objects made from eggs.

Corpus Christi Procession

Like many Bavarian communities, Oberammergau also hosts a festive Corpus Christi procession sixty days after Easter Sunday. After a solemn service in the Catholic Church of Saints Peter and Paul the colorful procession winds singing and praying through town, where flags wave from the festively decorated houses. In keeping with tradition, a statue of the Madonna is carried by the single women members of the society for traditional costumes. The procession of the faithful stops at various altars set up outdoors and then turns back towards the church.

The first Corpus Christi procession in Bavaria took place in 1273 in Benediktbeuern. As in other Catholic communities, today in Oberammergau the holiday of Corpus Christi is celebrated with a Mass and festive processions.

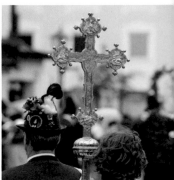

On scarcely another occasion can so many magnificent flags of the town's numerous associations and societies be seen. On the previous evening, if the weather is nice, there is a parade with the brass band and the drum corps of Oberammergau's music society.

King Ludwig's Fire

Already during King Ludwig II's lifetime, a fire to honor his birthday was lit on Oberammergau's own Mount Kofel. Only two years after his death this tradition was adopted by the people of Oberammergau, who have lit King Ludwig's Fire on the evening before his birthday, 24 August, every year since then.

Weeks earlier the so-called firemakers haul the firewood up the mountain along small paths known only to them and construct an over-twenty-five-foot-high royal crown on its peak; on a section of the mountain just below, a giant wooden cross is erected. But not only the firemakers climb up the mountain: Also the musicians of Oberammergau's brass band scale Mount Kofel in order to open Ludwig's fire with a choral as soon as dark-

ness falls and then accompany the lightning with music. While they play, the fire on Mount Kofel is lit, as are fires in six other places on the mountains around Oberammergau, some in the form of an "L," a Cross, or a great pile of wood. As the fires on the mountains slowly die down, the firemakers and the musicians descend into town by torchlight, where they celebrate together in the inns until the early morning hours.

Feast of the Holy Cross and the Mountain Masses

Mountain Masses and open-air church services have a long tradition in Oberammergau and its neighboring communities. On the early evening of 14 September, Oberammergau celebrates the Feast of the Holy Cross with a festival service on the Osterbichl hill at the Crucifixion group (see p. 33). The church choir and Oberammergau's music society provide musical accompaniment. When the service is over, the mountain riflemen form a guard of honor.

This tradition can be traced back to the former Oberammergau parish priest Franz Dietl—present auxiliary bishop of Munich and Freising—who, over twenty years

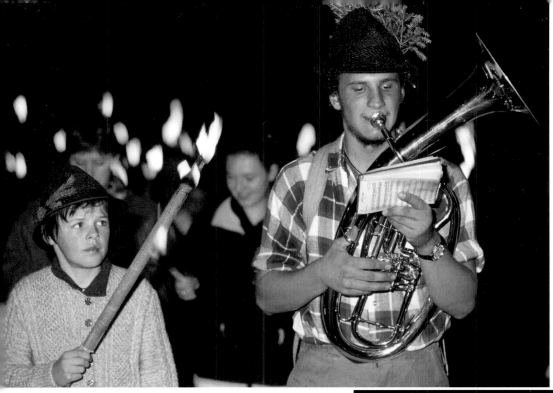

A long torchlight procession accompanies the musicians and firemakers through town.

Each year on 24 August, King Ludwig's Fire burns on Mount Kofel in honor of the fairy-tale king.

ago, began to incorporate the special spirituality of the place into church events and celebrate the Cross as a sign of salvation over Oberammergau.

In the summer more mountain services are celebrated all around Oberammergau; their schedule varies from year to year and can be found in the respective calendars of events.

Saint Leonhard's Ride in Unterammergau

On the last weekend of October a festive horseback procession in honor of Saint Leonhard of Limoges takes place in Unterammergau. A long, beautifully decorated procession makes its way from the center of Unterammergau to the Kappel pilgrimage church, where Holy Mass is celebrated and the blessing of the horses takes place.

Christmas Fair and Advent Singing

Traditionally the first Sunday of Advent in Oberammergau is devoted to the Christmas fair, which, after a morning church service, is ceremoniously opened on the church square by Oberammergau's wind quartet. In addition to

While the Christmas fair takes place on the first Sunday of Advent in the church square, the Christmas market is set up around the Pilate House on the third and fourth Sundays of Advent.

Starting point for the *Sterngang* or procession of the star on New Year's Eve. One of the stations at which the traditional songs are sung is the Pilate House.

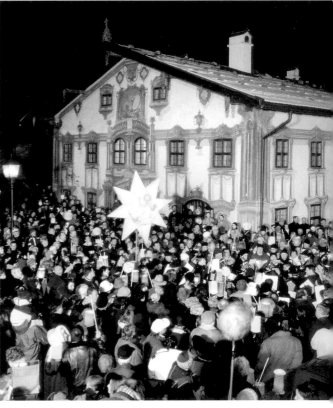

culinary delicacies, the Christmas fair offers handmade Christmas ornaments, candles, crèche figures, floral arrangements for Advent, and much more. Each year the proceeds benefit a charitable organization. The Christmas fair ends with festive Advent singing in the parish church of Saints Peter and Paul.

Christmas Arts and Crafts Market

Crèche makers, glassblowers, porcelain painters, wood-carvers and wood painters, basket weavers, soap makers: Over fifty artisans from Oberammergau and its surrounding area come every year on the third Sunday of Advent to the Ammergauer Haus for the Christmas Arts and Crafts market. Anyone still searching for a Christmas gift will certainly find it here.

Oberammergau's Christmas Market

On the third and fourth Sundays of Advent the enticing fragrance of spiced wine, cloves, and cinnamon wafts through wintry Oberammergau once again: The stands of the Christmas market are full of delicacies, handmade crafts, Christmas tree ornaments, and unusual wares, inviting the visitor to discover.

Christmas Caroling

Klöpfelsingen or Christmas caroling by children on the Thursday before Christmas Eve is the pre-Christmas parallel to the *Sternsingen*, or Star singers, in January and has survived in Oberammergau as an old Christmas tradition. The children go from house to house and announce the upcoming Christmas celebration with Christmas carols. The theme of their songs is Advent as a time of preparation for the great holiday and of reflection about the essential things in life as well about the importance of charity.

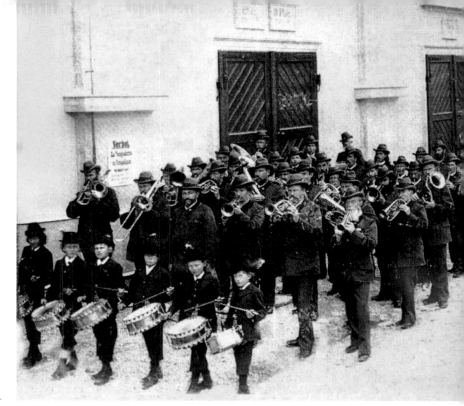

So-called Turkish music, the Oberammergau brass band at the end of the nineteenth century. 'Turkish music' at the time referred to a musical ensemble with brass and woodwind instruments accompanied by drums and cymbals. Until the turn of the century, the latter were not always common in brass bands.

Sterngang

On New Year's Eve Oberammergau is the scene of an especially festive tradition, the *Sterngang*, or procession of the star. Around 7:00 in the evening both inhabitants and guests gather together and parade through the town with a large illuminated star and many colored lanterns. Accompanied by singers and musicians, traditional songs are sung at various places within the town, including the song "The Christmas Star," whose text was penned by the parish priest Joseph Alois Daisenberger and given music by Rochus Dedler. At the end of each station the chorus of voices is raised in the traditional Bavarian New Year's greeting.

Oberammergau's Traditional Clothing

When King Maximilian II roamed through the Bavarian Alps in the middle of the nineteenth century to propagate the simple life and foster Bavarian folkways, traditional Bavarian clothing and folk music suddenly became the focus of interest by those in authority: Traditional regional clothing was not only acceptable at the salons, it was downright beloved at official functions. By special order of the king, the Upper Bavarian regional government even issued a directive for the preservation of traditional costumes. The people of Oberammergau had no need of such a directive, for here the wearing of traditional clothing had always been cultivated, even if the inhabitants had adopted bourgeois clothing habits for everyday life.

Many visitors to the Passion were disappointed at not finding the 'Turkish music' (brass band) dressed in traditional clothing, which was reserved for special occasions. "The city dwellers would not truly drive for twenty-five hours by postal coach to see new white trousers and black tuxedoes," wrote the reviewer Guido von Görres in the middle of the nineteenth century. On 20 July 1893 the D'Ammertaler society for traditional costumes was founded to preserve the traditional regional costume, songs, folk music, and *Schuhplattler* dance in Oberammergau; it is one of the oldest such societies in the Ammergau Alps and continues even today to enrich Oberammergau's cultural life with numerous events. Special credit is due the society for having revived Oberammergau's old traditional costume in the 1970s.

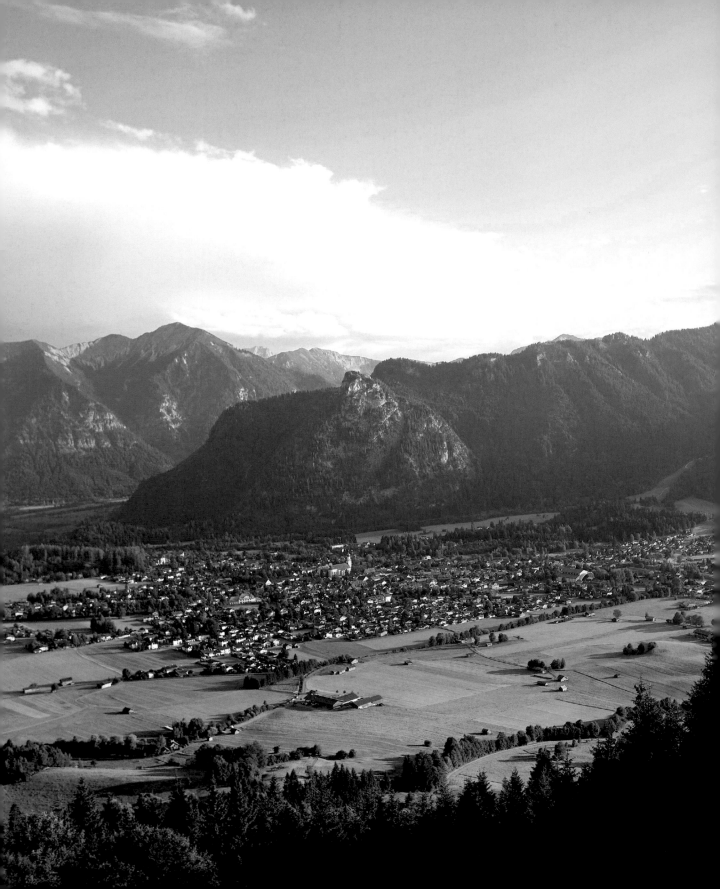

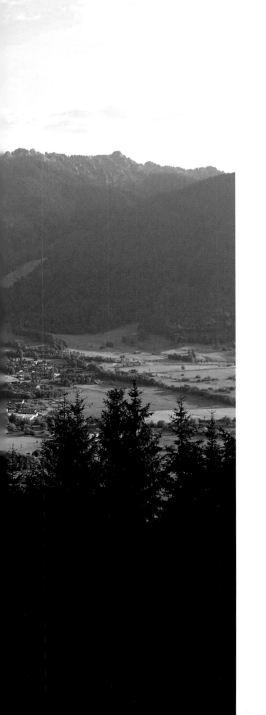

A VISIT TO THE AMMER VALLEY:
A Vacation Paradise

"Stopping place for all tourists; moderate prices; guest rooms with good beds, electric light; and fresh coffee daily.
Honored guests most graciously welcomed ..."

From the advertising copy for an Oberammergau hotel at the beginning of the previous century

From the Scheibum, the spectacular gorge of the Ammer River, a wonderful hiking path leads to the Schleierfälle waterfalls near Saulgrub.

Right: Summer and winter brochures from 1931–32

Facing page: A mysterious place surrounded in legend: the Schleierfälle waterfalls, whose water is fed by a spring and flows in small rivulets over the moss-covered stone, are not only worth visiting in summer, but also in winter, when the water freezes into bizarre icicles.

Unspoiled Nature

The Ammergau Alps have been a nature preserve since 1926. Their almost 70,000 acres make them the largest contiguous nature preserve in Bavaria and the second largest in Germany; only North Frisia's Wadden Sea has a larger area.

The Ammer River, whose sources lie between Graswang and Ettal, flows northwards from Weilheim into the Ammersee and then continues as the Amper, emptying into the Isar River near Moosburg. The Alpine river is approximately 185 kilometers (about 115 miles) long and contains the 600-meter-long (about 373 miles) Scheibum, the longest canyon-like expanse of ravine of any river in Germany. At this point the Ammer reaches a depth of eighty meters. The measures taken to protect against flooding along the Ammer have led to a reduction of its natural course in places, but many rare species of flora and fauna nonetheless find ideal living conditions in the nature preserve of the Ammer Valley.

Nature and Culture: From Mountain Bliss to Fairy-Tale Castle

Whether seeking one's bliss on the top of one of the many mountains surrounding Oberammergau or standing spellbound by the crystal-clear source of the Ammer River in Weidmoos, riding snug and comfortable in a horse-drawn carriage to Linderhof Palace or taking the children on one of the thrilling nature tours with promising names like "Scene of the Crime: Stalking Deer at the Staffelsee with the Nature Detective," Oberammergau is an ideal location for superb cultural excursions or strolls in nature, in which the interests of children and adults can be easily combined. And even the dog doesn't have to stay at home, since Oberammergau has had its own doggie hotel for several years.

The Ammergau Alps' meditation path leads from the Wieskirche via the Kappel to Linderhof Palace. It invites visitors to hike and linger meditatively along fifteen stations, as for example here at the Christuskreuz on the Altherrenweg near Unterammergau. The trail is marked by the symbol of the burning heart, which leads the hiker to places of special power whose histories are told on charming steles.

Facing page: It is well known that the sensational view from Mount Laber attracts many visitors and is popular both with hikers and skiers. But the rides up the mountain during the full moon are still a genuine insider's tip.

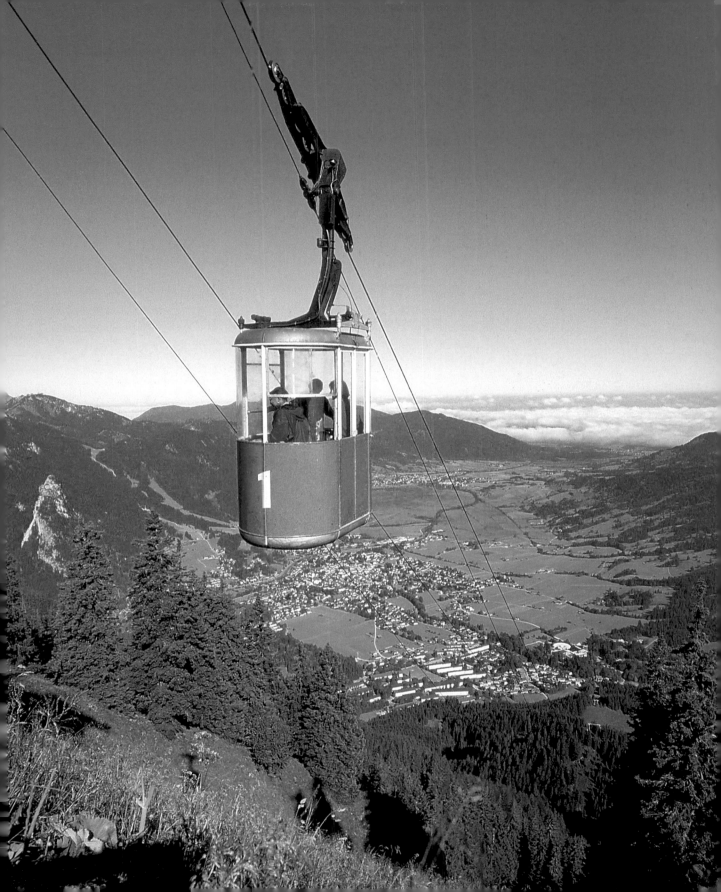

The last few hundred feet of altitude on the striking peak of Mount Kofel lead along a secured via ferrata, or fixed-aid climb that is also suitable for families.

Facing page:

Top: Around Oberammergau there are countless hiking possibilities for every taste, from flat valley hiking trails, through demanding ascents to the summit, to treks lasting several days, for example along the European long-distance paths, which lead through the Ammergau Alps.

Bottom: The Pulvermoos nature preserve between Oberammergau and Unterammergau provides the habitat for rare species of flora such as the globeflower, the moor-king, and the heath spotted orchid (l. to r.).

Steeped in Legend: Oberammergau's Mount Kofel

The fastest climber in town makes it in nineteen minutes, at a leisurely pace it takes about an hour and a half to ascend Mount Kofel. But it is not speed that draws people to Oberammergau's local mountain, nor is it necessarily its height, which, at 1,341 meters (about 4,370 feet), is not among the region's great mountains. They come instead because of Mount Kofel's very special character, which one senses already at its foot on the so-called Puzzle Path and at the excavations at the adjacent Döttenbichl (see p. 18). According to legend, between the thick forest and the sheer rock face, high up on Mount Kofel lives the Kofel witch; this has been told to the children in town for generations.

Every year on 24 August Mount Kofel is lit up at night, for this is when the people of Oberammergau celebrate their friend and patron King Ludwig II on the evening before his birthday: They light King Ludwig's Fire in his honor (see p. 94). From the mountain's summit one can take the Königsteig trail to the Kolbensattel, which one can also reach comfortably from Oberammergau with the chairlift. Oberammergau's second local mountain, the slightly higher Mount Laber at 1,684 meters (about 5,525 feet), stands directly across from Mount Kofel.

Mount Laber: Upper Bavaria Lies at Its Feet

The view from Mount Laber, which incidentally possesses Germany's "blackest ski slope" and is especially appreciated by freeriders, is simply breathtaking: To the north, one can see far into the Alpine uplands, and even Munich's Frauenkirche can be seen when the visibility is good. To the east, from south to west, in an incomparable mountain panorama stretch the ranges of the Estergebirge with its peaks Wank, Fricken, and Krottenkopf; the

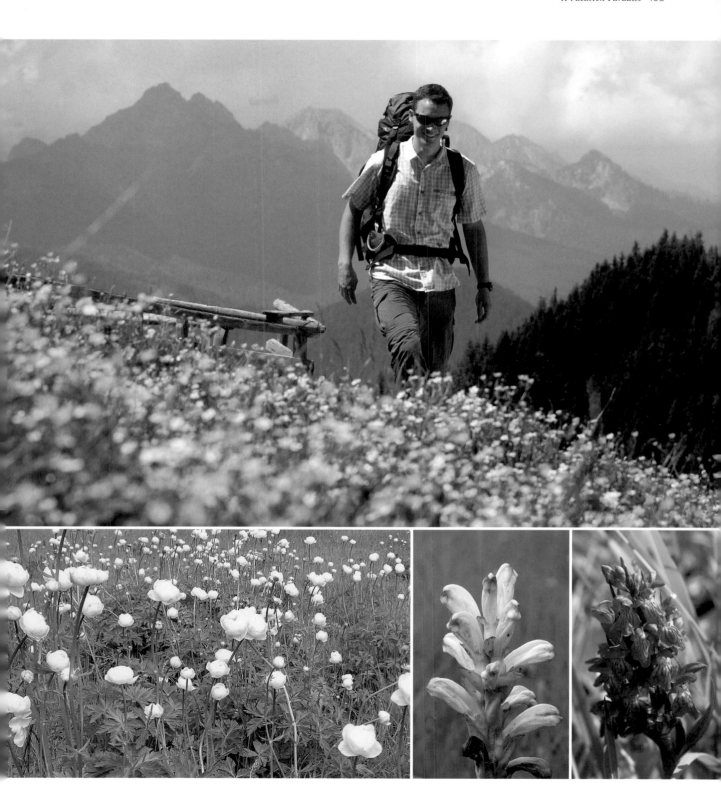

On hot days the wild and romantic Schleifmühlklamm gorge near Unterammergau is an ideal destination; here there is not only magnificent natural beauty to delight the viewer but also engrossing information about the quarrying of grindstones previously carried out here.

Wettersteingebirge with Germany's highest mountain, the Zugspitze (2,962 meters, or about 9,718 feet); and the Ammergauer Alps. The summit of Mount Laber, directly below the plateau of the alpine guesthouse, is a popular starting point for kite fliers and paragliders.

Visitors should not miss taking a ride on Mount Laber's aerial tramway, for here, despite all the modern technology, the good old days can still be felt. After a quick look at the chapel of Saint Gregory, built in 1765, just below the station, the visitor is wafted up to the summit in the nostalgic aerial tramway. For those who would rather walk to the top, the summit of Mount Laber can be reached in about two

and a half hours, and hikers can then descend, for example, via the Soilasee and the Ettaler Mandl (1,633 meters, or about 5,358 feet) to Ettal, or they can chose another hiking trail that leads back to Oberammergau. For a refreshing conclusion to the hike, the hiker is invited to take a dip in the WellenBerg adventure baths with its landscape of various pools.

The Pulvermoos:
A Paradise for Rare Species of Flora and Fauna

Between Oberammergau and Unterammergau lies the Pulvermoos nature preserve and Oberammergau's Wies-

The Pulvermoos was formed after the melting of the Ammer glacier over 10,000 years ago and is one of Europe's most important valley marshlands.

mahd, which extend along the valley underneath the mountain range from the Großer Aufacker to Mount Hörnle.

Rare species of flora and fauna can be found in this unique cultural landscape, an indication of the health of the region's nature: Here the visitor comes across butterflies with evocative names like dryad, map, poplar admiral, and purple emperor as well as red kites and black kites in the air; these birds of prey became established in the region only a couple of years ago.

By joining the town's ambitious bat-keeper, the visitor can even see a nursery roost of the Whiskered Bat or Brandt's Bat—a female and her young—who hide during the day under the shelter of a specific haystack.

Whether on foot, on bike, or in the winter on cross-country skis, it is possible to reach numerous destinations on the extensive network of hiking trails through this delightful landscape: to Kappel and the Schleifmühlklamm gorge near Unterammergau, to the ravine where the Ammer cuts through the rock face—the Scheibum—and to the Schleierfälle or waterfalls there, to Lake Soiener near Bad Bayersoien, or to the world-famous Wieskirche in Steingaden.

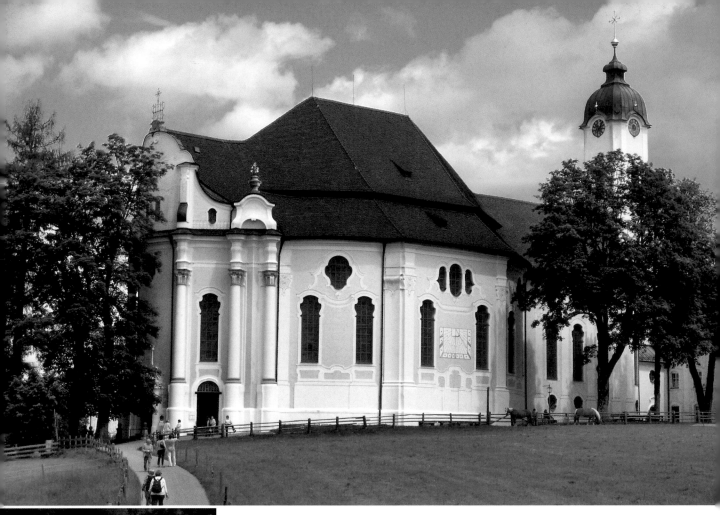

Left: On the road from Ettal to Oberammergau just before the town line, a cave known as the Bärenhöhle, or cave of bears, can be found on the right; at its entrance is a statue of Jesus blessing.

Previous double page: Swimming, fishing, and boating in the summer, and ice skating in the winter: The idyllic Lake Soiener near Bad Bayersoien is a popular destination for outings, and is only a few miles from Oberammergau.

The rococo jewel in so-called Pfaffenwinkel near Steingaden: The Wieskirche, pilgrimage church of the scourged savior

World Heritage Site Wieskirche

About twenty-five kilometers (fifteen and a half miles) northwest of Oberammergau is Germany's best-known World Heritage Site, the Wieskirche, or Wies Church. Constructed between 1745 and 1754 by the brothers Dominikus and Johann Baptist Zimmermann, this pilgrimage church is one of the most beautiful rococo churches in Germany and, with its magnificently decorated church space, symbolizes the feeling of the times as no other church in southern Germany. A special auditory experience is provided by the four-part baroque chimes, which are rung every Saturday at 3:00 in the afternoon and on Sundays before Mass. Its full chiming with all seven chimes is reserved for Catholic solemnities, or principal holy days.

In the Graswang Valley is the nature preserve Ettaler Weidmoos, where the wellsprings of the Kleiner Ammer River can be found (lower right).

The Graswang Valley

King Ludwig II was already fascinated by the beauty of this valley and had his palace Linderhof built here; he survived to see its completion, and it is the only one of his palaces where he actually lived.

Meandering, almost level, hiking and biking trails lead through the valley to the Weidmoos, one of Bavaria's most internationally significant marshes, known for its magnificent flowers. Not only do over twenty species of wild orchids and protected species of flora bloom in this unspoiled nature, but the moor is also a refuge for butter-flies of almost tropical beauty as well as protected birds and other species of fauna. On the Kleiner Ammer,

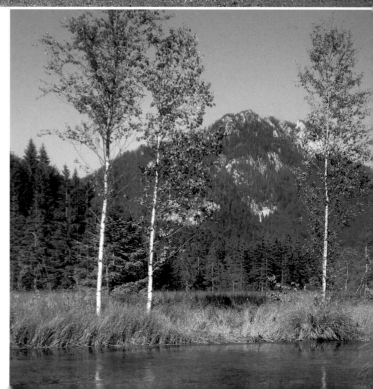

In winter, horse-drawn sleighs carry visitors through the Graswang Valley from Oberammergau to Linderhof Palace.

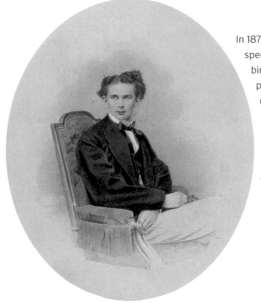

In 1877, King Ludwig II gave himself a special gift on his thirty-second birthday: the Venus Grotto in the park of Linderhof Palace. There, during his mostly nocturnal visits, he had a servant row him around in a precious rowboat shaped like a mussel shell; the lake was set in motion by a wave machine.

a small branch of the Ammer River, the common kingfisher moves into its winter quarters, the beaver builds his dams in Weidmoos, and for a few years now the golden eagle has made its home in the mountains above the Graswang Valley. He can be especially easily observed during the mating season in winter when he courts his mate with dynamic aerial maneuvers.

Many of the wellsprings of the Kleiner Ammer can be found in the Weidmoos, some of them hidden, others clearly visible. The crystal-clear spring water, from which small bubbles rise, collects first in wellsprings before converging into a stream, the Kleiner Ammer, which finally, in a wider streambed, becomes the River Ammer.

Linderhof: King Ludwig II's Favorite Palace

King Ludwig II's palaces, which he built only for himself and were never to be entered by a stranger—since his death, however, there have been over fifty million visitors—were for him "poetic places of refuge, where it was briefly possible to forget the terrible times in which we live."

King Maximilian II, King Ludwig II's father, had already built hunting lodges on Mount Pürschling—today the site of the German Alpine Club lodge August-Schuster-Haus—and at the far end of the Graswang Valley already in 1854–55. King Ludwig loved this region, less because of the hunting and more for its idyllic seclusion: "Peace reigns in the deep valleys, the ringing of cowbells, the song of a shepherd rise up to my sweet seclusion," he wrote in a letter to Richard Wagner on 21 June 1865. A few years later he first had additions made to the hunting lodge in the Graswang Valley, then had it removed to a new location, and finally, from 1874 to 1879, had a "royal villa" built in rococo style on the site: Linderhof Palace. It is the smallest of this three palaces—after Neuschwanstein and Herrenchiemsee—but is considered to have been his favorite, since he spent most of his time here. Linderhof's magnificent interior fulfills every expectation of a fairy-tale palace. Guided tours of the palace and park, some offered especially for children, bring King Ludwig and his time to life again with fascinating details and information.

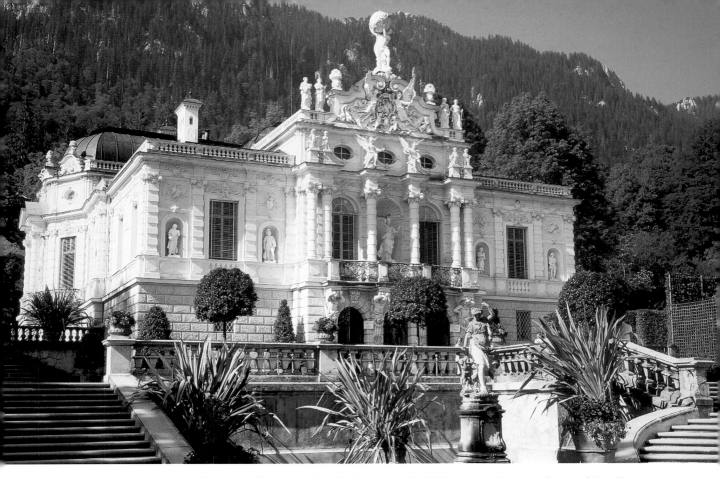

Ludwig II's admiration for the mystical world of the Orient, the chivalrous-romantic Middle Ages, and the magnificence of Versailles are mirrored in the architecture of Linderhof Palace and its park complex.

Linderhof Palace lies in the middle of one of the most beautiful gardens of the nineteenth century, designed by the Munich Hofgarten director Carl Joseph von Effner. It delights the visitor not only with its magnificent baroque and Italian Renaissance garden design but also the ingenious technology of its fountains and water cascades. Not only the Moorish Kiosk and the Moroccan House, but also the Temple of Venus, Hunding's Hut, the Music Pavilion, and the Hermitage of Gurnemanz invite the visitor to enter the world of the Orient or the scenes of Richard Wagner's operas, as King Ludwig himself once did. King Ludwig wrote of himself to his governess Sybille Meilhaus, with whom he remained in written contact all his life, "I hope to remain an eternal riddle, to myself and to others." This enigmatic quality has continued to fascinate people even today and is one of the reasons for the immense interest and

veneration they show to their "kini," as many Bavarians affectionately refer to their former king.

Today Oberammergau can be reached by car from Munich in about an hour, and with the train it takes exactly an hour and fifty-one minutes, but until the end of the nineteenth century the journey resembled an arduous pilgrimage, and required two days. The first leg of the journey was with a horse-drawn wagon from Munich to Murnau, where travelers spent the night and started out the following morning for Oberau. From there they had to scale Mount Attal on foot until the improvement of the new road there in 1890. Then as now, after the steep ascent, the climber is rewarded with the inspiring sight of the Abbey of Ettal with its mighty baroque dome, which has remained the spiritual and cultural center of the Ammer Valley since its founding.

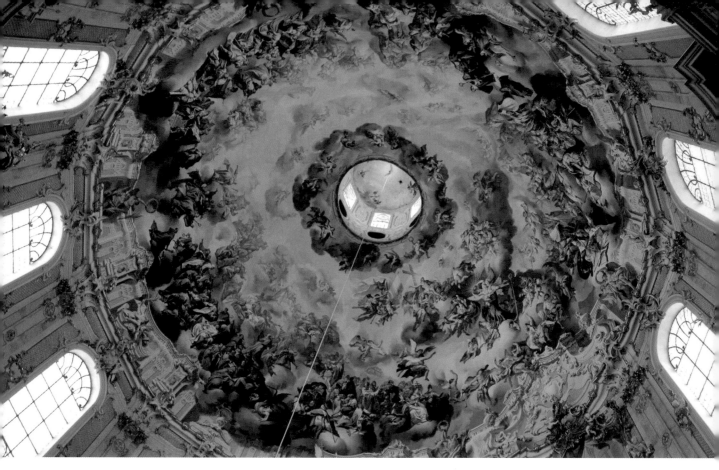

The dome fresco of the Ettal basilica was painted in 1752 by Johann Jakob Zeiller. It shows over 400 saints of the Benedictine order and its branches from various epochs of ecclesiastical history.

The Abbey of Ettal

The Abbey of Ettal was founded in 1330 by Emperor Ludwig the Bavarian in fulfillment of a vow. The emperor brought a small white marble figure of the Madonna to the foundation; this miraculous image still stands in the abbey church and has drawn countless pilgrims to Ettal.

In 1710 the abbey adopted once again the original idea of an associated knights' academy, thus laying the foundation stone for Ettal's academic tradition. Almost the entire abbey complex was destroyed in a devastating fire in 1744. Reconstruction was carried out in rococo style after plans by Enrico Zuccali and Joseph Schmuzer.

The interior of the baroque dome is decorated with Johann Jakob Zeiller's impressive ceiling painting; he also painted Ettal's famous rococo sacristy. In 1803 secularization brought an abrupt end to almost five hundred years

of abbey life. This lasted for almost a hundred years, until on 6 August 1900 Benedictine monks were allowed to move into the abbey once again and return it to its original purpose. Since then, in the tradition of the knights' academy founded in 1710, the secondary school and the boarding school there have come under the administration of the Benedictines in the Abbey of Ettal.

In addition to visiting the abbey complex, a visit to the Brewing Museum, the distillery, and a tour of the cheese dairy offer the visitor a fascinating and informative glimpse into the abbey's various operations.

Kandinsky and Company: Der Blaue Reiter in Murnau

Just like Oberammergau, Murnau too was under the jurisdiction of the Abbey of Ettal until 1803. For 400 years the of-

Coming from the Laberjochhaus in the direction of Ettaler Mandl, hikers pass by Lake Soilasee, which, unfortunately, no longer has nearly as much water as in this photograph, and is silted up for a large part of the year.

ficial seat and residence of the keeper from Ettal was Murnau Castle, which now houses the Murnau Schlossmuseum. The museum's main concentration is the most extensive publicly exhibited collection of works by Gabriele Münter as well as works by the artist group Der Blaue Reiter, whose members were important pioneers of twentieth century art, among them Wassily Kandinsky, Franz Marc, Alexej Jawlensky, Marianne von Werefkin, and Heinrich Campendonk.

Long before the founding of Der Blaue Reiter the artist couple Kandinsky and Münter had discovered Murnau and surroundings. The natural beauty of the landscape around Murnau and Bavarian folk art (see p. 83) inspired not only the two of them to pioneering works, but also Franz Marc, who created some of his most important works in this area, including *Blaues Pferd* (*Blue horse*) and *Kleine gelbe Pferde* (*Small yellow horses*).

In this house, also called the Münterhaus, Gabriele Münter and Wassily Kandinsky lived in the summer months between 1909 and 1914. The furniture and stairs painted by Kandinsky show the significant influence of Bavarian folk art on the artistic development of its occupants.

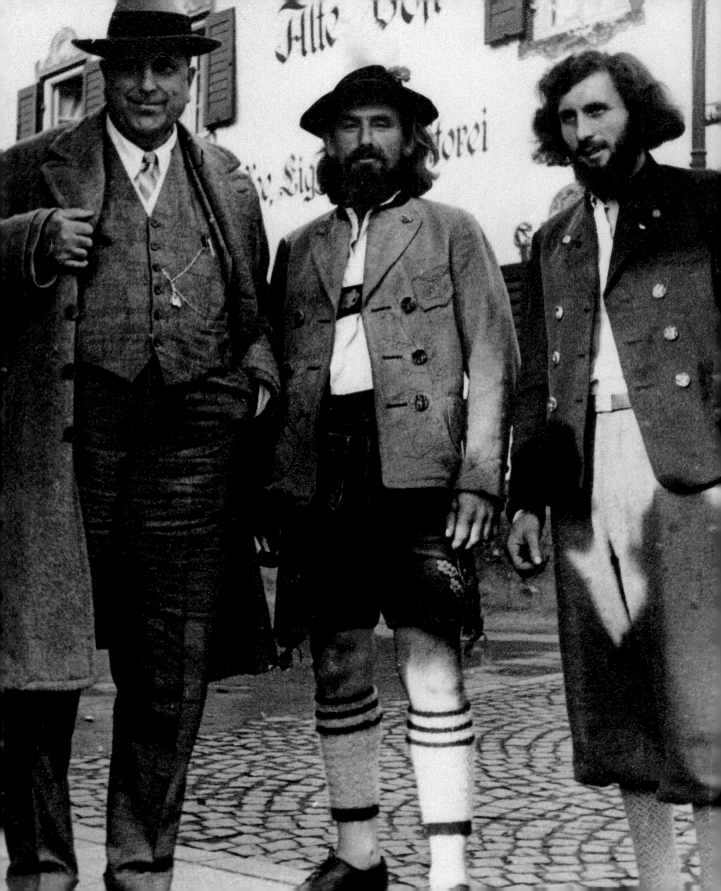

FAMOUS GUESTS,

Historical Luminaries

"One evening I received an invitation to the home of [the actor playing] Christ, [Joseph] Mayr. I can no longer remember which lords and ladies, mistresses and misses the hosts had gathered together; of the locals, the actors in the lead roles and the notables were present with their ladies ... But beforehand and at the table these people from Oberammergau spoke and moved so naturally and unaffectedly, and yet so graciously, that one actually had the feeling that attending such an event was not unusual for them but a constant routine. Most of them were able to converse impeccably with the foreigners in their native languages."

From *Oberammergau. Bilder und Gestalten. Erinnerungen*, (Oberammergau: images and shapes: memories), around 1922 by Ferdinand Feldigl, Oberammergau teacher in 1901-02

"Come to Us in Oberammergau"

Joachim Ringelnatz

The entries in the Golden Book of the community of Oberammergau and in the guest books of the guesthouses and inns, some of them over 150 years old, read like a Who's Who of world history. Since the nineteenth century at the very latest, Oberammergau has attracted artists, high dignitaries of the Church, politicians, the high aristocracy, and industry magnates, many of whom also visited outside of the Passion play season. Next to their signatures, they often wrote personal dedications in the guest books, reflecting their amiable relationship to Oberammergau and their hosts. Lifelong friendships developed, and many guests became benefactors of the village though generous donations.

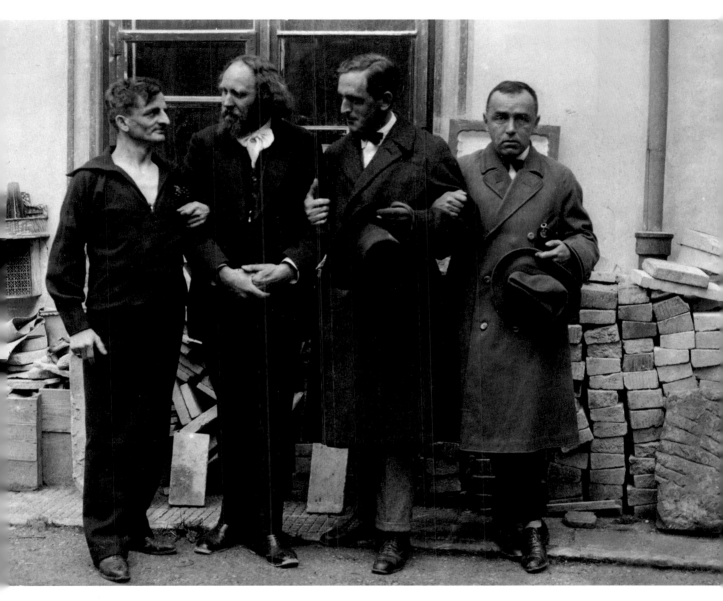

Joachim Ringelnatz (far left) posing in the Passion play year 1922 with the actor playing Christ, Anton Lang, and his two friends from *Simplicissimus*, Adolph Köster and Peter Scher

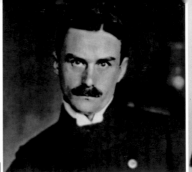

Ludwig Thoma

Ludwig Ganghofer
(Drawing: Olaf Gulbransson)

Thomas Mann

Gustav V, King of Sweden

Ludwig Thoma

Ludwig Thoma, born in Oberammergau and related to the Lang family on his mother's side, actually wanted to become a forester like his father, then pursued a degree in law, which, however, did not interest him for long. In 1897 he gave up his practice in Dachau and settled in Munich as a writer. There he made contacts with the artists of the satirical magazine *Simplicissimus* and became one of its most important editors. By the time of his death forty books had appeared, of which his *Lausbubengeschichten* (Rascal stories), the *Filserbriefe* (Jozef Filser's correspondence) and the *Heilige Nacht* (Silent night, holy night) are among his most famous. Thoma visited the Passion plays in 1900 together with his *Simpl* friends Rudolf Wilke, Ferdinand von Rezniček, Bruno Paul, and Eduard Thöny, and stayed with them at the business quarters of his nephew Guido Lang. He enjoyed the play immensely and so in 1910 he watched the performance twice, even if he was not so fond of the crowds.

Ludwig Ganghofer

With his folk play *Der Herrgottschnitzer von Ammergau* (The crucifix carver of Ammergau) Ludwig Ganghofer created a monument to Oberammergau and its tradition of woodcarving. At the beginning of the twentieth century, his novels, stage plays, and writings made him one of the most successful authors of his time. The enthusiastic hunter was a frequent guest in the Werdenfelser Land region and, like his friend Ludwig Thoma, was one of the prominent visitors to the 1900 Passion plays.

Thomas Mann

"In the summer we often stayed in the country, in Oberammergau, where I wrote most of *Royal Highness* ..." Thomas Mann wrote in his *Lebensabriß* (A sketch of my life) of 1930 about his three-month summer sojourn in Oberammergau with his family. Many more visits followed, and always gave the writer renewed strength and energy for his work. During the Christmas of 1929, shortly after receiving the Nobel prize for literature for *Buddenbrooks*, Mann wrote in the guest book of his guest house: "With gratitude for four peaceful days during a personally turbulent time."

Gustav V, King of Sweden

The reigning Swedish king at the time, King Gustav V, visited the Passion plays in 1910 and was so taken with

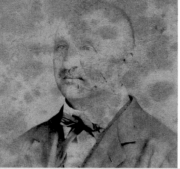

Joachim Ringelnatz

Anton Bruckner

Marie Bartl

Pope Pius XII

them that after the performance he summoned for the actor playing Christ (Anton Lang) and the speaker of the prologue (Anton Lechner), and conversed with them at length. He presented his host Joseph Ruederer with the signed portrait above.

Joachim Ringelnatz

In his poem "Snow" of 1933 Joachim Ringelnatz dedicated to the people of Oberammergau the verse "Come to us in Oberammergau. Christ and love are here, and our snow shines with blue of heaven." Before beginning his career as a cabaret artist, writer, and painter, Ringelnatz—actually Hans Gustav Bötticher—had made his home at sea as a sailor. During the time between voyages he scraped by on adventurous side jobs, for example as a boa constrictor carrier at the annual fair, disguised as a fortune-teller at a bordello, and as a girl Friday in a home for sailors.

Anton Bruckner

While visiting the 1880 Passion plays, at the age of fifty-six, the composer fell in love with the young Oberammergau local Marie Bartl, whom he discovered among the actresses playing "weeping women." He courted her

and gave her the photograph above with a dedication shortly after his departure. Bruckner wrote Marie numerous letters, many of which never reached her for some reason. His love remained unrealized, and he never returned to Oberammergau.

Marie Bartl

During the time she was courted by Anton Bruckner, the lovely Oberammergau local Marie Bartl was working for Korbinian Rutz. She later married an Oberammergau woodcarver and never revealed the content of the letters she received from her admirer.

Pope Pius XII

Pope Pius XII—at the time of this photograph during the Passion plays of 1922 still Cardinal Pacelli—was pope of the Roman Catholic Church from 1939 to 1958.

Rabindranath Tagore

The Indian poet prince Rabindranath Tagore, who in 1913 became the first Asian to win the Nobel prize for literature, composed the majority of his works in Bengali and later rendered them himself into English, doing so in

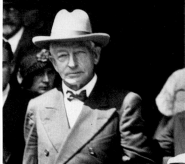

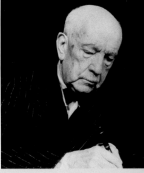

Rabindranath Tagore Henry Ford William Randolph Hearst Richard Strauss

such an accomplished style that they became highlights of European literature. On his last visit to Germany in 1930 he not only met with Albert Einstein to exchange ideas, but was also a guest at the Oberammergau Passion plays.

Henry Ford

The American automobile king and founder of Ford Motor Company, Henry Ford enjoyed Oberammergau so much during his visit to the Passion plays in 1930 that he extended his stay by two days. He also seemed taken with Bavarian cuisine: Over the protest of his wife he went into the kitchen of his guest house shortly before his departure and requested the recipes for some of the dishes he had found especially delicious.

William Randolph Hearst

Even though the American publisher and media tycoon William Randolph Hearst had lost a substantial amount of money in 1929 he was still among the richest men in the world when he came to Oberammergau to the Passion plays in 1934. After making plans to dine at the Hotel Wittelsbach, an elaborate meal was prepared for

him there. But when he finally arrived his first wish was for only one thing: frankfurters. The photograph on p. 118 shows Hearst with two Passion actors.

Richard Strauss

In 1909 Richard Strauss, who penned such famous operas as *Elektra* and *Der Rosenkavalier* (The knight of the rose), built himself a villa in Garmisch-Partenkirchen, just over twelve miles from Oberammergau, where he spent the final years of his life. In 1910 he came to Oberammergau with his wife Pauline, his son Franz, his publisher Otto Fürstner, and friends to see one of the fifty-six performances. Richard Strauss was not only a loyal visitor to the plays, but also visited Oberammergau frequently between Passion seasons, to visit good friends.

General Eisenhower

Dwight D. Eisenhower, supreme commander of allied forces in Europe during the Second World War and later president of the United States (1953–61), visited the "peace plays" in 1950 together with his wife Mimi. There he met political representatives such as German president Heuss,

General Eisenhower

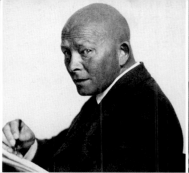
Olaf Gulbransson

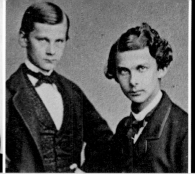
King Ludwig II with
his brother Otto (left)

Edward VII, King of England

chancellor Adenauer, and the Bavarian minister president Ehard. Since 2003 Oberammergau has had an Eisenhower Museum that retells the story of "Ike" in many interesting and surprising exhibits.

Olaf Gulbransson

The Norwegian painter and caricaturist Olaf Gulbransson came to Oberammergau for the Passion plays in 1910 together with his second wife Margarethe "Grete" Jehly, an Austrian writer. As an artist for Munich's satirical magazine *Simplicissimus* he visited Oberammergau often with his friends. In 1929 he settled in Tegernsee, where today there is a museum dedicated to his extensive oeuvre.

King Ludwig II

A special performance of the Passion was staged on 25 September 1871 for King Ludwig II, shown here with his brother Otto. It is said that the king invited the leading actors to a reception at Linderhof Palace. Georg Lechner, the actor playing Judas, was, according to his son, asked by the king with a piercing look, "Judas, what did you feel as you betrayed the Lord?" This look—and even the mem-

ory of it later—was said to have made the actor "break out in a cold sweat." In contrast, Joseph Mayr, the actor playing Christ, was treated more favorably and invited several times to visit the king, who showed Mayr his palace under construction and expressed his displeasure at the slow progress of the work.

Edward VII, King of England

King Edward VII traveled incognito together with his wife in 1871 to the Passion plays in Oberammergau and stayed with Sebastian Zwinck. A special relationship developed between the host and the king, who had not yet been crowned. When Edward VII was not able to visit Oberammergau in 1880 due to illness, he wrote to Zwinck excusing his absence. For King Edward's coronation in 1901 Sebastian Zwinck carved him a scene of the Last Supper, whereupon the king invited him to England and presented him with a coronation medallion.

Index

Photo Credits

Alzheimer, Heidrun: *Einmal Oberammergau und zurück*, Oberammergau 1999: p. 65 far left (photo: Photoarchiv Ellen Maas, Frankfurt/Main)

Ammergauer Alpen GmbH: back cover: see p. 11 far left, p. 1 2nd from left; p. 1 3rd from left, p. 24 lower left, p. 44 bottom, p. 91 (photo: Oberammergau Tourismus); p. 1 4th from left, pp. 2–3, p. 30 top, p. 43, p. 95 bottom, p. 96 l. and r. (photo: Eberhard Starosczik, Oberammergau); p. 4, pp. 66–7, p. 93, pp. 98–9 (photo: Florian Wagner, Munich); p. 10 2nd from left, p. 74 (photo: Stefan Höcherl, Munich); p. 12; p. 11 2nd from left, pp. 14–15, p. 18, p. 28, p. 37 bottom, p. 80, p. 83 r., pp. 86–7, p. 101, p. 107, p. 110 bottom, p. 111 top and bottom (photo: Horst Preisenhammer, Oberammergau); p. 19, p. 92, pp. 112–13 (photo: Hans Peter Schöne, Uffing); p. 26, p. 105 top (photo: Peter Hutzler, Munich); p. 31 (photo: Hanna Glaser, Winnweiler); p. 33 lower right, p. 105 bottom (photo: Manfred Müller, Oberammergau); p. 41 r., p. 102–3, p. 117 top (photo: Bernd Ritschel, Kochel am See); p. 45 top (photo: Thomas Dashuber, Munich); p. 22, p. 49, p. 106, p. 116 (photo: Stephan de Paly, Dresden); p. 69 upper left and bottom; p. 8, p. 11 1st from left, p. 13 3rd and 4th from left, p. 30 bottom, p. 83 left, p. 84, p. 89 upper left and bottom, p. 90, p. 95 top,

p. 104 (photo: Thomas Klinger, Oberammergau); pp. 108–9 (photo: Daniela Blöchinger, Munich); p. 110 top (photo: Jörg Christöphler, Munich)

Bildagentur Huber: Front cover, p. 23

Bogenrieder, Dr. Frz. X.: *Oberammergau*, Diessen 1930: pp. 20, 59 upper right (photo: Hermann Rex, Oberammergau)

Brandl, Anton: p. 50, p. 65 2nd and 3rd from left, p. 94 (all)

Buchwieser, Annelies: *Oberammergau damals und heute*, Oberammergau 1984: p. 35 left

Dashuber, Tomas: *Ecce homo. Oberammergau 2000*, Munich 2000: p. 56, p. 57 (all), p. 58 top, p. 65 4th from left (photo: Tomas Dashuber, Munich)

Gemeindearchiv Oberammergau: p. 17 bottom, p. 34 bottom, p. 38 top, p. 40, p. 41 left p. 48 2nd and 3rd from left, p. 53 bottom, p. 55 (all), p. 58 bottom, p. 59 bottom, p. 60 r. and inside back jacket flap, p. 69 center, p. 100 2nd and 3rd from left, p. 118, p. 123 2nd and 3rd from left, p. 124 3rd from left (detail, see p. 118), p. 124 4th from left, p. 125 far left, p. 125 6th from left.

Günzler, Otto/Zwink, Alfred: *Oberammergau*, Munich 1950: p. 121, p. 122 4th from left, p. 123 far left

(detail, see p. 121), p. 123 4th from left, p. 124 1st and 2nd from left (photo: H. Kronburger, Oberammergau)

Henker, Michael (ed.): *Hört, sehet, weint und liebt. Passionsspiele im alpenländischen Raum*, Munich 1990: p. 48 left, p. 61 (all; photo: Ewald Haag, Oberammergau); p. 53 top (photo: Theatermuseum der Universität zu Köln)

Klinner, Helmut W.: *Oberammergau in Aufnahmen seines ersten Fotografen, Korbinian Christa (1854–1916)*, Horb am Neckar 1997: p. 10 far left (detail, see p. 97), p. 97 (photo: Korbinian Christa, Oberammergau)

Lang, Anton: *Aus meinem Leben*, Munich 1930: p. 38 bottom

Lang, Florian: p. 1 far left, p. 11 3rd from left, p. 13 2nd from left, p. 16, p. 24 r. and inside front jacket flap, p. 25, p. 32 top, p. 33 upper right, p. 34 top, p. 35 r., p. 37 top, p. 39, p. 64 1st and 2nd from left, p. 69 upper right, p. 73 r., p. 77 and inside front jacket flap, p. 81, p. 88 bottom, p. 122 far left, p. 125 3rd from left

Oberammergau Museum: p. 13 far left, p. 36 (all), p. 48 4th from left, p. 68, p. 70, p. 71 (all), p. 72 (all), p. 73 top, p. 75 (all) and front jacket flap, p. 76, p. 78 (all), p. 79 (all), p. 82

Passion 2000. Oberammergau, ed. by the Gemeinde Oberammergau, Munich

2000: inside front jacket flap: 1633, inside back jacket flap: mid-19th c., 1950 and 2000; pp. 6–7, p. 10 3rd from left, p. 46–7, p. 51, p. 62, p. 64 3rd and 4th from left (photo: Brigitte Maria Mayer, Berlin)

Passionsspiele 2010 Oberammergau, Press Office: p. 27 (all), p. 42, p. 44 top, p. 45 bottom, p. 52 (all), p. 54, p. 59 upper left, p. 60 left

Pörnbacher, Hans: *Oberammergau*, Munich 1988: p. 21, p. 24 upper left (photo: Vitus Fenzl, Oberammergau); p. 29 (all; photo: Annelies Buchwieser, Oberammergau); p. 85, p. 100 far left (photo: Frederic Grawe, Oberammergau); p. 89 upper right (photo: Anton Bartl)

Prestel archives: p. 33 left, p. 114, p. 115, p. 117 bottom, p. 122 2nd and 3rd from left, p. 125 2nd from left

Rädlinger, Christine: *Zwischen Tradition und Fortschritt. Oberammergau 1869–2000*, Oberammergau 2002: p. 32 bottom (photo: Stadtarchiv München)

100 Jahre Volkstrachtenverein "D'Ammertaler", Oberammergau 1993: p. 88 top

Acknowledgements

We are grateful to the following persons for help with the content and visual material of this publication:

Markus Gerum | Nature guide
Otto Huber | Deputy Director and Dramatic Adviser of the Passion Play 2010
Helmut W. Klinner MA | Head of the Community Archives Oberammergau
Florian Lang | Lang Family Archives
Ute Oberhauser | Marketing & Sales Ammergauer Alpen GmbH
Dr. Constanze Werner | Head of Oberammergau Museum

And to the following for important information and additional support:

Jörg Christöphler | Managing Director Ammergauer Alpen GmbH
Nicole Richter | Assistant Managing Director Ammergauer Alpen GmbH
Ignaz Schön | Oberammergau Tourism
Ludwig Utschneider MA | Historischer Verein Oberammergau 1999 e.V.
Franz Windirsch | Druckerei Fritz Kriechbaumer

Picture credits: p. 127

Front cover: The Pilate House from the yard
Back cover: Dancing child (see p. 11 far left)
Front jacket flap: Trickster on a string, see p. 75
Back jacket flap: Map of Oberammergau
pp. 2–7: In the Ammergau Alps, Oberammergau handicrafts (detail, see p. 66), Passion Play 2000: The choir
p. 8: On the dance floor (detail, see p. 89)

Prestel Verlag, Munich
A member of Verlagsgruppe Random House GmbH

Prestel Verlag
Königinstrasse 9
80539 Munich
Tel. +49 (0)89 24 29 08-300
Fax +49 (0)89 24 29 08-335

www.prestel.com

Prestel Publishing Ltd.
4 Bloomsbury Place
London WC1A 2QA
Tel. +44 (0)20 7323-5004
Fax +44 (0)20 7636-8004

www.prestel.com

Prestel Publishing
900 Broadway, Suite 603
New York, NY 10003
Tel. +1 (212) 995-2720
Fax +1 (212) 995-2733

Library of Congress Control Number is available; British Library Cataloguing-in-Publication Data: a catalog record for this book is available from the British Library; Deutsche Nationalbibliothek holds a record of this publication in the Deutsche Nationalbibliografie; detailed bibliographical data can be found under: http://dnb.d-nb.de

Prestel books are available worldwide. Please contact your nearest bookseller or one of the above addresses for information concerning your local distributor.

Translated from the German by Cynthia Hall

Project management: Gabriele Ebbecke
Editorial direction: Beate Besserer
Edited | Copyedited by Cynthia Hall
Art direction: Cilly Klotz
Production: Christine Groß
Design and layout: Stefan Engelhardt, Mühldorf am Inn, and designwerk Wolfram Söll, Munich
Origination: Reproline Genceller, Munich
Printing and binding: Druckerei Fritz Kriechbaumer, Taufkirchen

Printed in Germany on acid-free paper

ISBN 978-3-7913-5023-3 (English edition)
ISBN 978-3-7913-5022-6 (German edition)